MONTEREY FIRE DEPARTMENT

Images of America

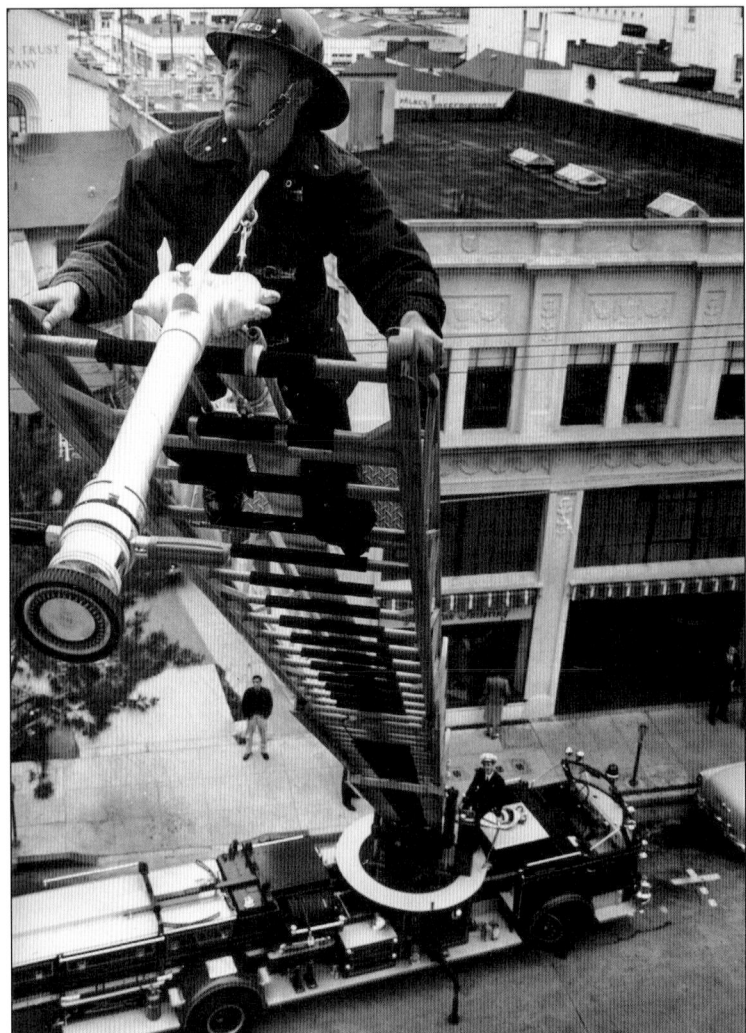

On March 30, 1960, firefighter Charles "Ted" Bell peers from atop the new 1959 America LaFrance aerial ladder into the Professional Building, located adjacent to the old fire station on Calle Principal Street. The aerial ladder was capable of being extended out 85 feet and was a welcome sight. The ladder replaced the old Seagrave aerial that was on loan from the Naval Postgraduate School. The older Seagrave aerial had to be replaced because the ladder would lose its hydraulic pressure, causing the aerial to drop while firefighters were on the ladder. (Photograph by William L. Morgan, courtesy of the Monterey Fire Department.)

ON THE COVER: This photograph was taken in front of hose cart station No. 2 in New Monterey; the new hose cart company was formed on March 8, 1905. A Sanborn map dated 1912 locates a hose cart company at 518 Hawthorne Street, which is the approximate location of fire station No. 2 today. The firefighters are wearing belts with metal buckles engraved with the wording "Monterey Hose Co." The firefighter in the center is holding one of the early hose nozzles that were used to put water on the fire. The third firefighter from the left holds a speaking trumpet used to give orders at the fire. Young children of the firefighters hold a rope used to help rescue people or to secure equipment. (Photographer unknown, courtesy of the Monterey Fire Department.)

IMAGES of America
MONTEREY FIRE DEPARTMENT

Mike Ventimiglia

Copyright © 2012 by Mike Ventimiglia
ISBN 978-0-7385-7623-7

Published by Arcadia Publishing
Charleston, South Carolina

Printed in the United States of America

Library of Congress Control Number: 2011927876

For all general information, please contact Arcadia Publishing:
Telephone 843-853-2070
Fax 843-853-0044
E-mail sales@arcadiapublishing.com
For customer service and orders:
Toll-Free 1-888-313-2665

Visit us on the Internet at www.arcadiapublishing.com

To the firefighters of the Monterey Fire Department who proudly served the citizens of Monterey over the years with unselfish dedication

Contents

Acknowledgments 6

Introduction 7

1. Monterey Fire Chiefs 9
2. Fire Stations 21
3. Famous Cannery Row Fires 29
4. Large Commercial and Residential Fires 47
5. Fire Apparatus and Fireboats 67
6. Fire Department Personnel 79
7. Once upon a Time 121

Acknowledgments

This book would not have been possible if it were not for the work of William L. Morgan and his photographs of fires and firefighters that span nearly four decades. Upon his death, he donated his work to the fire department. Unless otherwise noted, all images in this book were taken by William L. Morgan and appear courtesy of the Monterey Fire Department. The author took the more recent photographs. Special thanks go to Crystal Lombardi for her assistance and support. Without the help of retired assistant fire chief Jack Reynolds, retired fire captain Charles "Ted" Bell, and retired fire captain Richard DeLorimier, many of the early firefighters pictured in this book could not have been identified. The aid of Dennis Copeland, the City of Monterey Museum director and archivist, was invaluable in the publishing of this book. Thanks go to fire chief Andrew Miller for providing the support and leadership that allowed me to write this book. I am grateful for the City of Monterey for having provided the means to conduct research on the various topics in this book in the California Room. In remembrance of the firefighters of the past for the tradition and pride they established, which has made the Monterey Fire Department it is today, we honor them. Thanks to William E. Parker, who was appointed the first fire chief and served for 52 years in that role with the department. Thanks to the individuals within the fire department who had the foresight to preserve 129 years of photographs, documents, and records that aided in the research in making this book possible. Thanks go the volunteers at the City of Monterey Library who have taken on the task of preserving the historical documents that were once stored by the fire department for all generations to enjoy.

Introduction

Having been dispatched by Philip III of Spain, Don Sebastian Vizcaino, with three vessels, embarked on a voyage along the coast of California. On December 10, 1602, he discovered and anchored in Monterey Bay. Don Sebastian Vizcaino took possession of the land in the name of the king of Spain; he named the spot Monterey Bay. On July 14, 1769, about 166 years after Don Sebastian Vizcaino landed in Monterey, explorer Gaspar de Portola set out on a voyage of rediscovery but failed in finding Monterey Bay. The third trip to Monterey proved successful when Fr. Junipero Serra sailed into Monterey Bay on June 3, 1770, and founded Mission San Carlos. Monterey Bay was later selected as the capital of Alta California. The military established the Presidio at Monterey, and over the next 100 years, the Presidio population continued to grow. The inhabitants of the Presidio began to move outside the fort and populate the surrounding area, which would become the town of Monterey. The town continued to grow, and the citizens established a firefighting force in 1882 with a bucket brigade. Manned with leather buckets, young muscular men would form a line and pass the buckets filled with water back and forth to throw water onto fires.

On March 22, 1884, Monterey fire protection was organized when a volunteer hose company was formed. The hose company numbered 25 men equipped with a small hand-drawn hose cart. On December 5, 1885, Monterey Hose Co. No. 1 appeared for the first time in their new uniforms. They paraded through the streets of Monterey in preparation for their first benefit ball. Adding interest to the benefit, a flag presentation by the hose company members occurred at the ball. Their uniform consisted of a high-crown black hat resembling the Grainger fire helmet, a red shirt with white buttons, a black belt, and dark pants. Each volunteer member paid for his own uniform. The fire lads were taking hold in providing fire protection in earnest to the town's people. They hoped that citizens would provide them with the necessary apparatus for an active fire department.

The first Monterey Volunteer Hose Company, organized in 1884, was charter by the city on March 4, 1890, and William E. Parker was named its fire chief. Chief William E. Parker would hold the position until 1942, serving 52 years as fire chief. He would be given the honor of being the nation's longest serving fire chief.

These fire companies made up of volunteers used hand-drawn fire apparatus to make their way to fires until 1916, when the city purchased its first mechanized fire apparatus, a 1916 Seagrave fire engine. Prior to this time, famous fires, like the burning of the new three-story schoolhouse on July 8, 1893, and the Last Chance Saloon fire on September 30, 1894, were fought by these gallant men pulling equipment across town to the fire.

Since its beginning as a volunteer fire company over 129 years ago, the fire department has played an important part in the city's history. The fire department is a dedicated firefighting organization as well as a social organization, as its members were and are comprised of prominent citizens. At one time, Monterey's main industries was fishing and canning; at the height of the

industry, there were approximately 19 canneries working along Ocean View, which later would be renamed Cannery Row. Over the years, these canneries were plagued with fires that tested the fire department and the men who served. Large amounts of fish oil, fish meal, and by-products of the canning process would impregnate the wood flooring and timbers. Whether accidental or deliberate, fires started in these canneries engulfed entire buildings and could be seen for miles. September 1924 brought two of the city's most historic fires, the burning of the Associated Oil tanks, which were struck by lightning, and the burning of the main building at the Hotel Del Monte. By the 1950s, the fishing industry had diminished, as the sardines that made Monterey famous disappeared. This left Cannery Row with large vacant canneries. Due to the economic downturn, the city was forced to redevelop, and it emphasis turned to tourism. Over the next 70 years, the city capitalized on the early Spanish history, and Cannery Row focused on characters like John Steinbeck, Edward Flanders, Robb "Ed" Ricketts, and Kalisa Moore. During this time of redevelopment and revitalization of Cannery Row, numerous fires occurred because it was more economical to burn the old canneries than to tear them down to clear the properties.

The fire department has changed along with the times—gone are the volunteers who gave so much of themselves. The city abolished the volunteer program in the late 1960s, when the fire department became a fully paid department. State and federal training standards mandated that the city drop its volunteer firefighting program. The Monterey Fire Department of today is working toward consolidating the area's fire departments to eliminate duplication of services and to help cost sharing in services provided to the citizens.

One
MONTEREY FIRE CHIEFS

The Monterey Fire Department has only had 11 fire chiefs over the last 129 years. The fire chief in the early fire department, which was mainly comprised of volunteers, was chosen from the volunteers within the department. This selection process did not always select the most competent person to lead the fire department, as most volunteer fire departments are social in nature, and often, a more popular individual was selected to head up the fire department. In 1890, when the City of Monterey chartered the fire department, it was crucial to select a strong leader and a person from within the fire department whom the firefighters respected. With his experience as an agent for Wells Fargo, William E. Parker possessed the management skills needed to fill the position of fire chief. The City of Monterey continued to fill the fire chief's position from within the ranks of the fire department until 1980, upon the retirement of fire chief Herbert O. Scales. All fire chiefs thereafter were selected from outside of the fire department. The process of filling the fire department's top position from outside the ranks of the fire department may provide a more efficient manager; however, in some cases, it can have a devastating effect on the moral of the firefighters, resulting in apathy within the fire department. Often, outside selections are made to remove the emotional bond that has built up over the years between the firefighters who work together and have gained the respect and support of the community and to quiet the fear that an individual from within cannot lead and manage the department. It is hopefully that this trend will cease in the future, and the city will once again select its fire chief from within the department. The following chapter will identify the men who served in the position of fire chief and what they brought to the department.

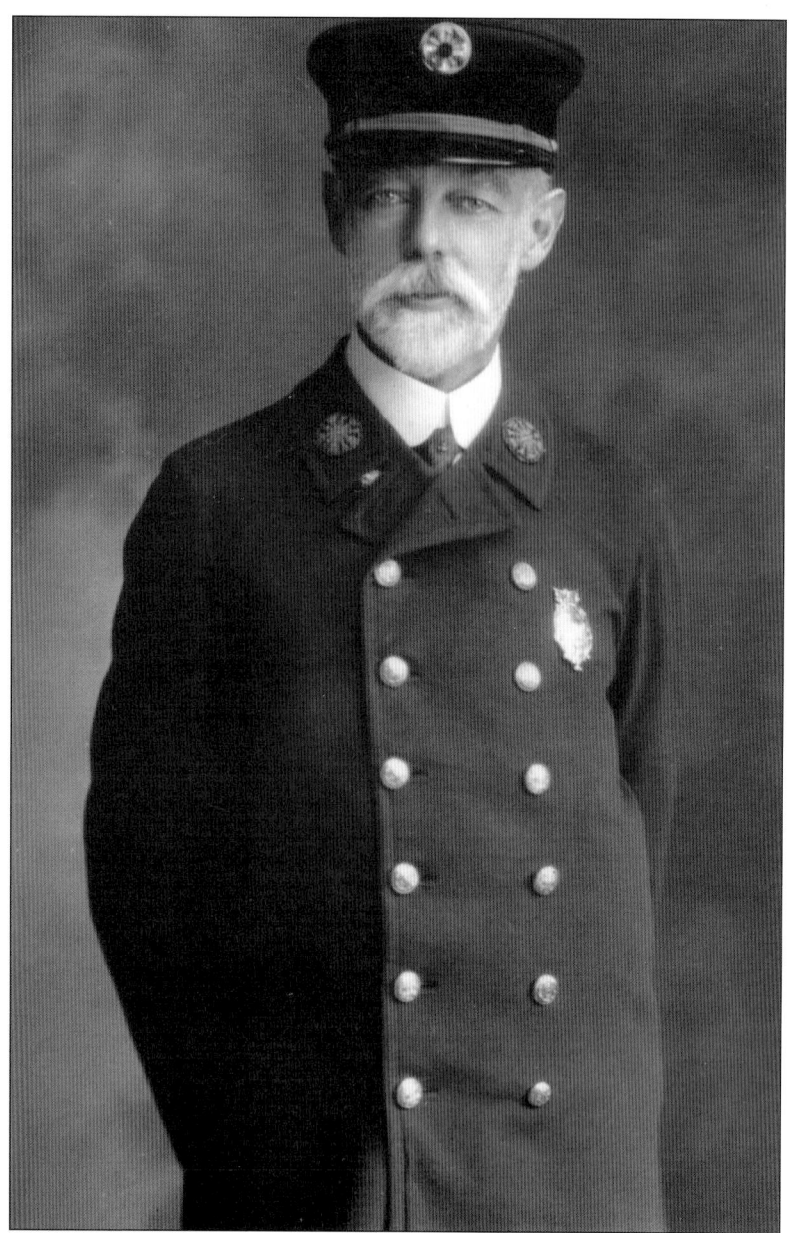

Born in Dutch Flat, California, on January 17, 1865, William E. Parker was assigned as a Wells Fargo employee in Monterey in 1887. He joined the fire department in 1888 when he became a member of hose company No. 1. On March 4, 1890, the city chartered the fire department and named William E. Parker as fire chief. He was also elected city clerk in 1906. It took a strong man to organize an effective firefighting force in those days. The two most notable fires that Chief Parker and his men fought were the Associated Oil tank fire and the Hotel Del Monte fire, which occurred 13 days apart in September 1924. He was behind the purchases of the city's first Gamewell Fire Alarm System and of the first fire engine, a 1916 Seagrave. His personnel and citizens held him in high esteem. He is recognized as the nation's longest actively serving fire chief, with 52 years of service. William E. Parker retired in 1942, and the 1916 Seagrave was retired from active service in 1956. (Photographer unknown, courtesy of the Monterey Fire Department.)

In 1942, Harvey T. Morgan was appointed fire chief upon the retirement of Chief William E. Parker. Morgan served as fire chief from 1942 until 1946. Chief Morgan was fired by the city council; newspaper articles reported that he was removed for inefficiency. In addition, the city council felt that Chief Morgan was not resolving the issue of large amounts of trash in the downtown area. Not much is known about Chief Morgan, except that he was out spoken regarding the city's water supply. He blamed the death of a small child that occurred in New Monterey on inadequate water supply. He also expressed the need for an aerial fire apparatus due to the multiple fires that occurred in the canneries, stating that the fire department was limited in its ability to fight these fires. Chief Morgan refused to leave his office and sued the city council. The story was carried in the local newspaper, exposing both Chief Morgan and the city council to public scrutiny.

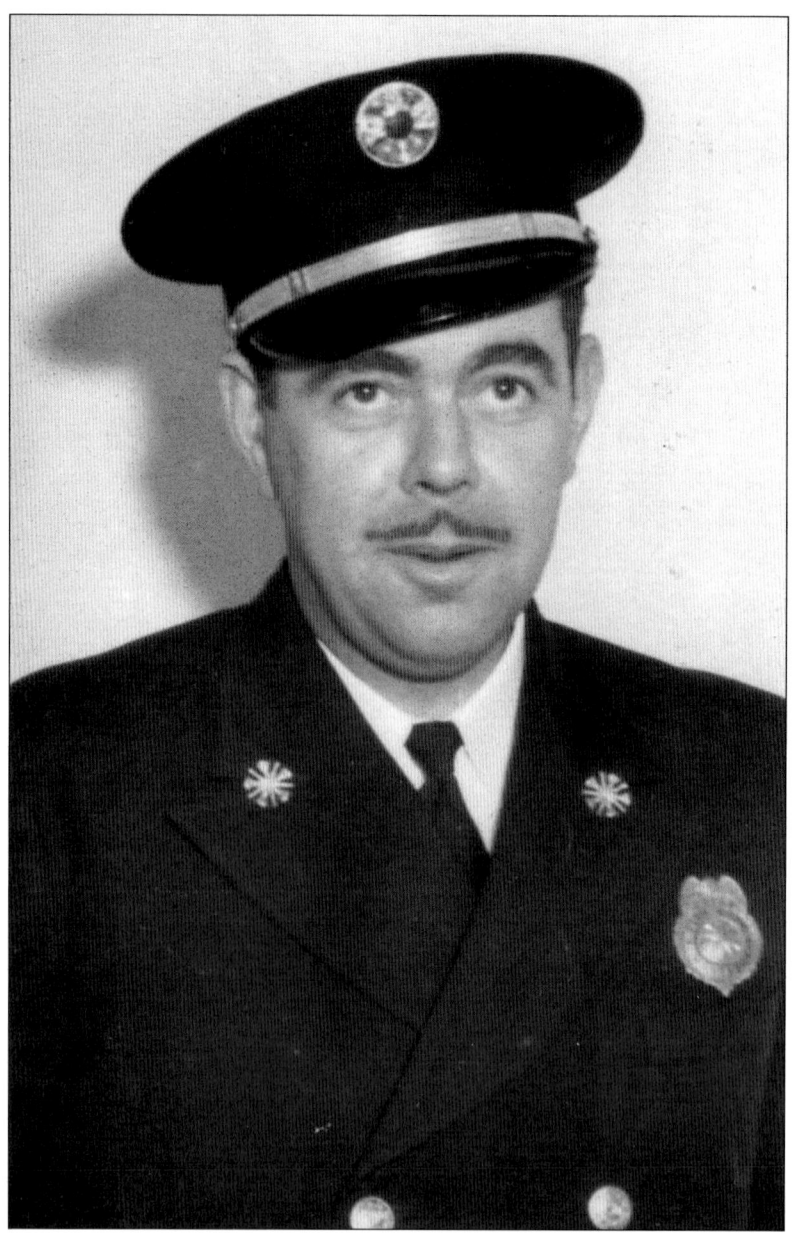

Gregory Teaby was appointed chief of the department in 1946. Chief Teaby began his career in the department in 1936. A native of Monterey, he attended Monterey schools and graduated from Monterey Union High School in 1931. In 1940, after serving three years as a volunteer, he became one on the department's full-time employees as an engineer. He acquired the fire department's first aerial ladder truck. He worked out an agreement with the Naval Postgraduate School for the use of the school's aerial ladder for fire protection. Chief Teaby had several disagreements with the city manager, Walter Hahn Jr., regarding wearing or not wearing his uniform. They struck a compromise that he was to wear his uniform 50 percent of the time. However, tension still existed between Chief Teaby and the city manager. After 19 years of service with the department, he resigned in 1955. Chief Teaby's father, Dr. Walter Teaby, was mayor of the city in 1934. (Photographer unknown, courtesy of the Monterey Fire Department.)

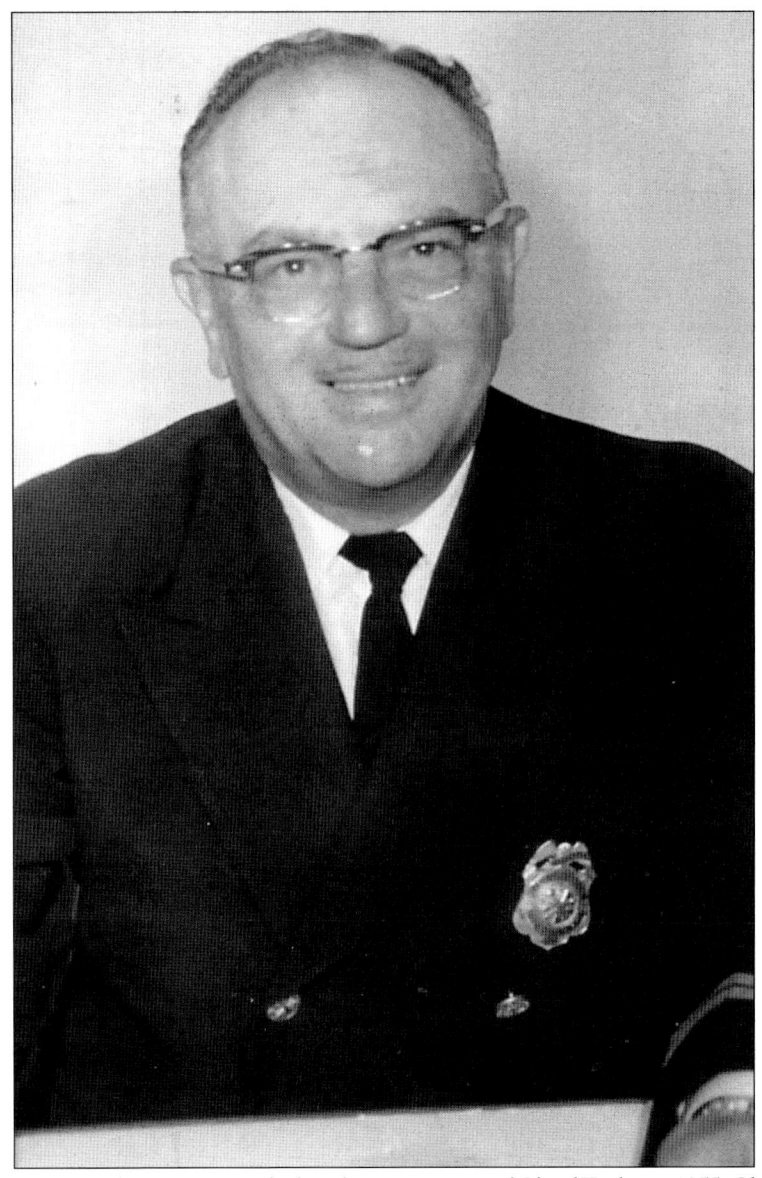

Chief Clifford Hebrard was appointed after the resignation of Chief Teaby in 1955. Chief Hebrard was the assistant chief under Teaby, and his background was in fire prevention. Chief Hebrard came up through the ranks of the department to command over many of the early cannery fires. Prior to being appointed fire chief, he was responsible for giving station assignments and scheduling days off for the firefighters. He was instrumental in the department's first prefire plan program, gathering information on building locations, contents, exits, and construction and putting the information in folders. This system of organization was the beginning of the fire prevention bureau. The information would be used to familiarize firefighters with buildings in the city. Chief Hebrard's strong suit was in fire prevention, and many of the early inspection programs within the department were developed by him. Also, he was the first fire chief to occupy the new headquarters fire and police station, built at Madison and Pacific Streets in 1959. Chief Hebrard held the position of fire chief until his retirement in 1969. (Photographer unknown, courtesy of the Monterey Fire Department.)

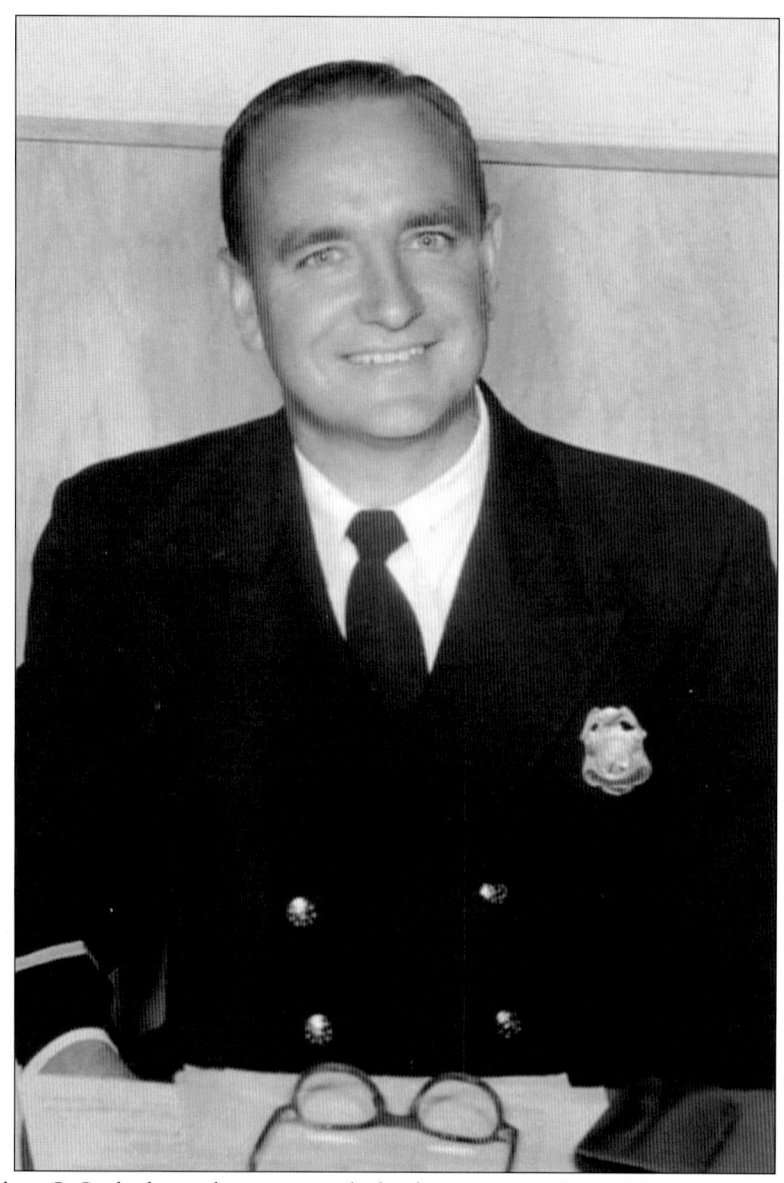

Chief Herbert O. Scales began his career with the department in June 1952. He previously worked as a firefighter for the City of Pacific Grove in 1949. He was the last fire chief to be promoted from within the ranks of the fire department. He served as chief from 1968 to 1980 and made significant changes. One controversial change was altering the color of the apparatus from red to lime yellow. In 1972, the department received two Seagrave fire engines painted lime yellow. Red, although traditional, was not readily a color visible at night; lime yellow yielded a greater visibility rating and reduced accidents while responding. He also recognized the ineffectiveness of the filtered canister mask the firefighters were wearing, which caused health problems. He expanded the self-contained breathing apparatus program to protect firefighters. Engine companies started responding to all medical emergencies instead of just heart attacks where a resuscitator was needed. Under his watch, the department responded to numerous abandoned cannery fires as development and tourism was emphasized. (Photographer unknown, courtesy of the Monterey Fire Department.)

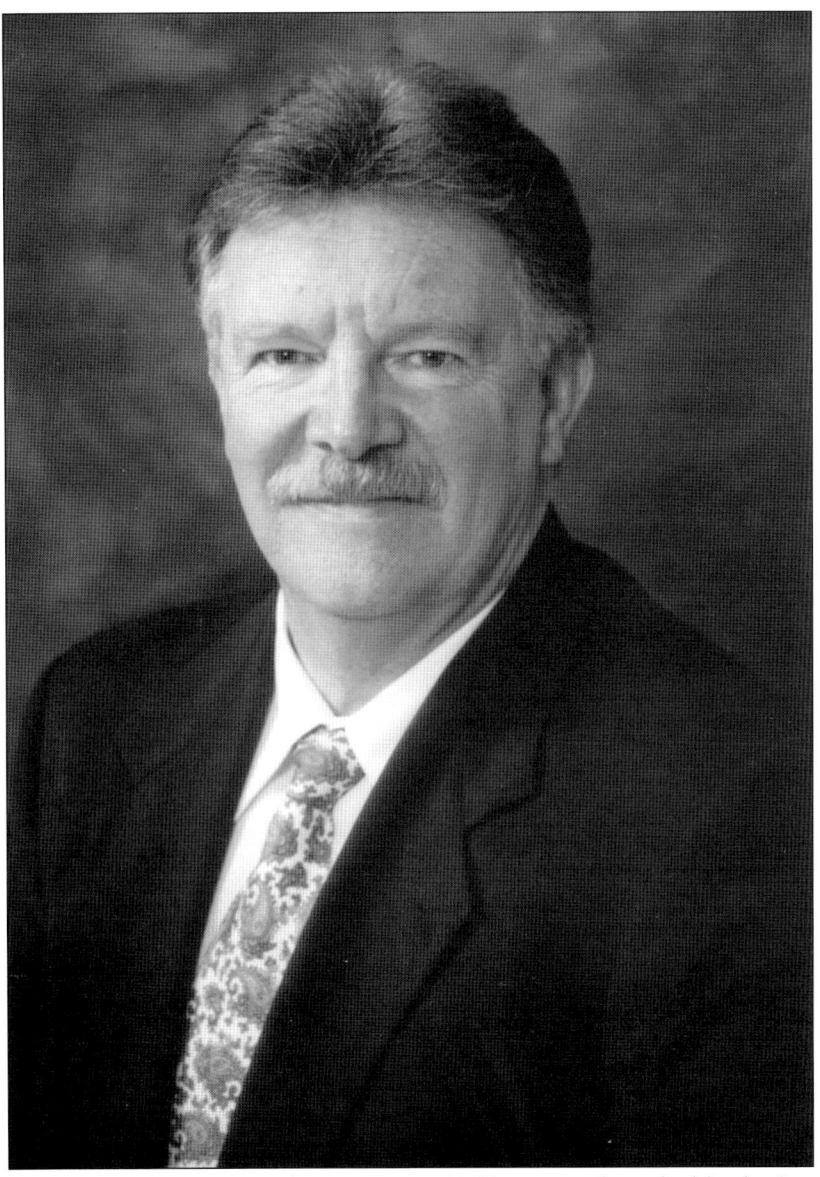

Chief John Montenero was appointed on June 23, 1980. He previously worked for the City of Corte Madera, where he held the position of chief. He introduced the five-inch fire hose supply systems to the department that are still in use today. Chief Montenero introduced participative management to the department. The department changed from an authoritative style of management to participative. Firefighters were empowered and given the responsibility to manage specific programs that were essential in departmental operations. He implemented cardiopulmonary resuscitation (CPR) classes for the public as self-help programs. When meeting with the public, chief officers' traditional uniforms were replaced with blazers and slacks. The firefighters grew under the participative style of management as the authoritarian style of management was phased out. Every firefighter was given an opportunity to participate in the decision-making process of the department and voice his or her opinions. Montenero resigned from the department on November 1, 1984, to become the fire chief in Glendale, California. (Photographer unknown, courtesy of the Monterey Fire Department.)

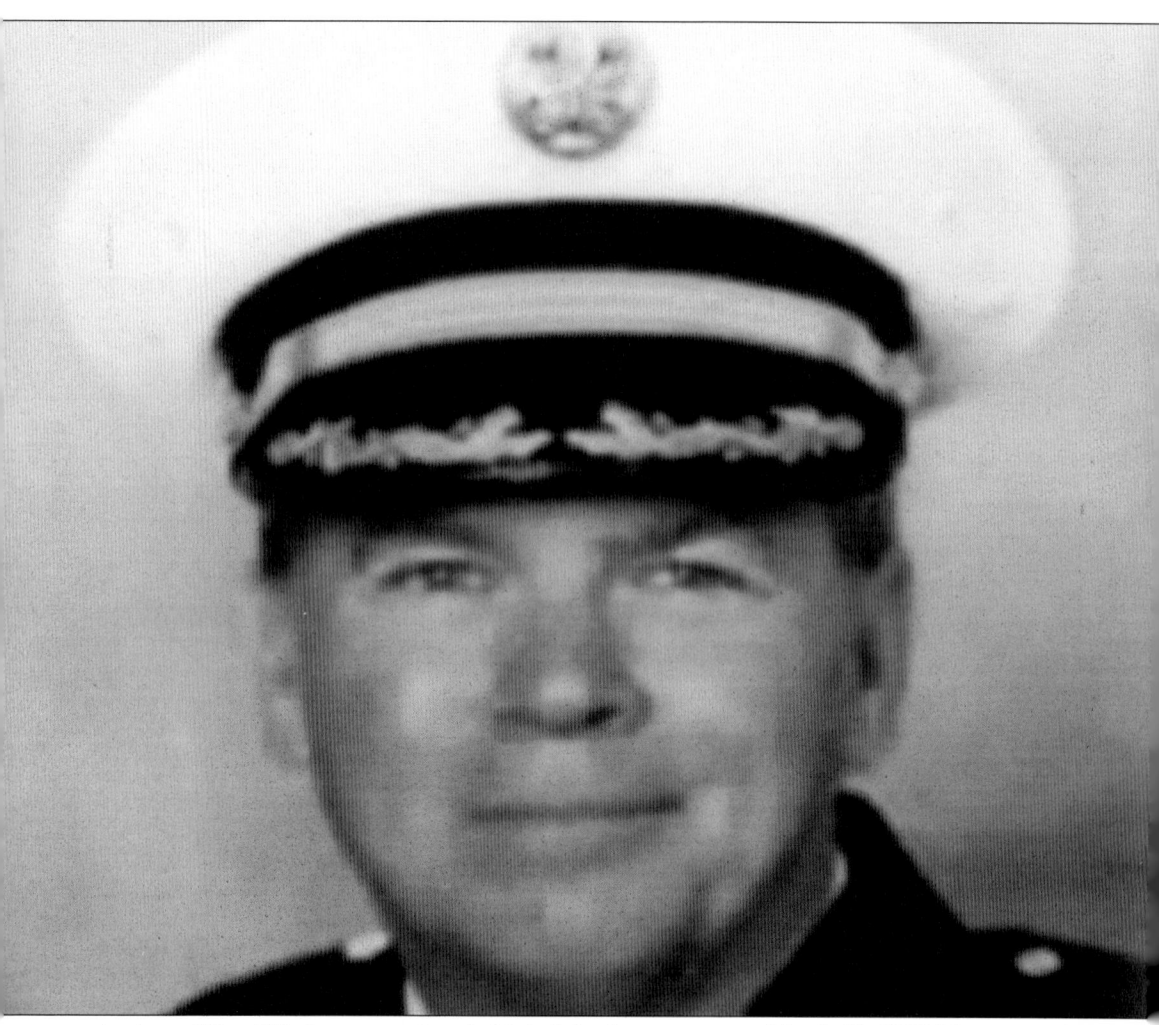

Anthony "Tony" Fink was appointed chief of the department on March 11, 1985. He previously served the City of Glendale, California, where he was the administrative fire chief. He was responsible for reinstating the engine company inspection program and fire prevention training for engine companies. Chief Fink established the hazardous materials fuel cleanup program, which meant engine companies would now absorb spilled fuel to protect the environment instead of washing the gasoline into the storm drains. Chief Fink was also instrumental in establishing the Medal of Valor within the department; presently only three firefighters have been awarded the Medal of Valor. Chief Fink underwent a strenuous time with the firefighters association, as they did not often see eye to eye. Chief Fink resigned on February 1, 1988, to take the position of fire chief in the City of Roseville. He served the City of Monterey less than three years. (Photographer unknown, courtesy of the Monterey Fire Department.)

Jack Meade was appointed as chief on September 19, 1988. He previously worked for the Merced Fire Department as the deputy fire chief. He was instrumental in acquiring a new aerial ladder. The platform-style aerial could be extended 105 feet in height from the street. He refined city disaster plans and encouraged citizens to take Neighborhood Emergency Response Training (NERT), which is now called Civilian Emergency Response Teams (CERT). The NERT program led to the construction of a new stand-alone emergency operations center. Chief Meade was also given the task of heading up discussions among local fire chiefs on consolidating area fire departments. One of the most dramatic changes in the department was the reassignment of the division chiefs, who were taken off shift and given duty assignments based on an eight-hour day, with rotating call back for emergencies. This was driven by city management and lasted approximately four years. After severing as fire chief for 10 years, Meade retired in 1998 on a medical disability. (Photographer unknown, courtesy of the Monterey Fire Department.)

Gregory Glass was appointed chief of the department on April 10, 2000. Chief Glass was formerly the chief for the City of Pacific Grove. Chief Glass was responsible for replacing the fire department's aging fleet of fire apparatus. Engines would often break down, causing the department to rely on older reserve fire apparatus to respond to emergencies. Under his leadership, the department gained new fire engines and a new wildland engine. Chief Glass increased fire department's resources that could be dispatched to emergencies when called for under the California State Mutual Aid Plan. He was helpful in the formulation of the urban search and rescue team in a joint effort with other local departments. Chief Glass retired from the department on February 13, 2006. (Photographer unknown, courtesy of the Monterey Fire Department.)

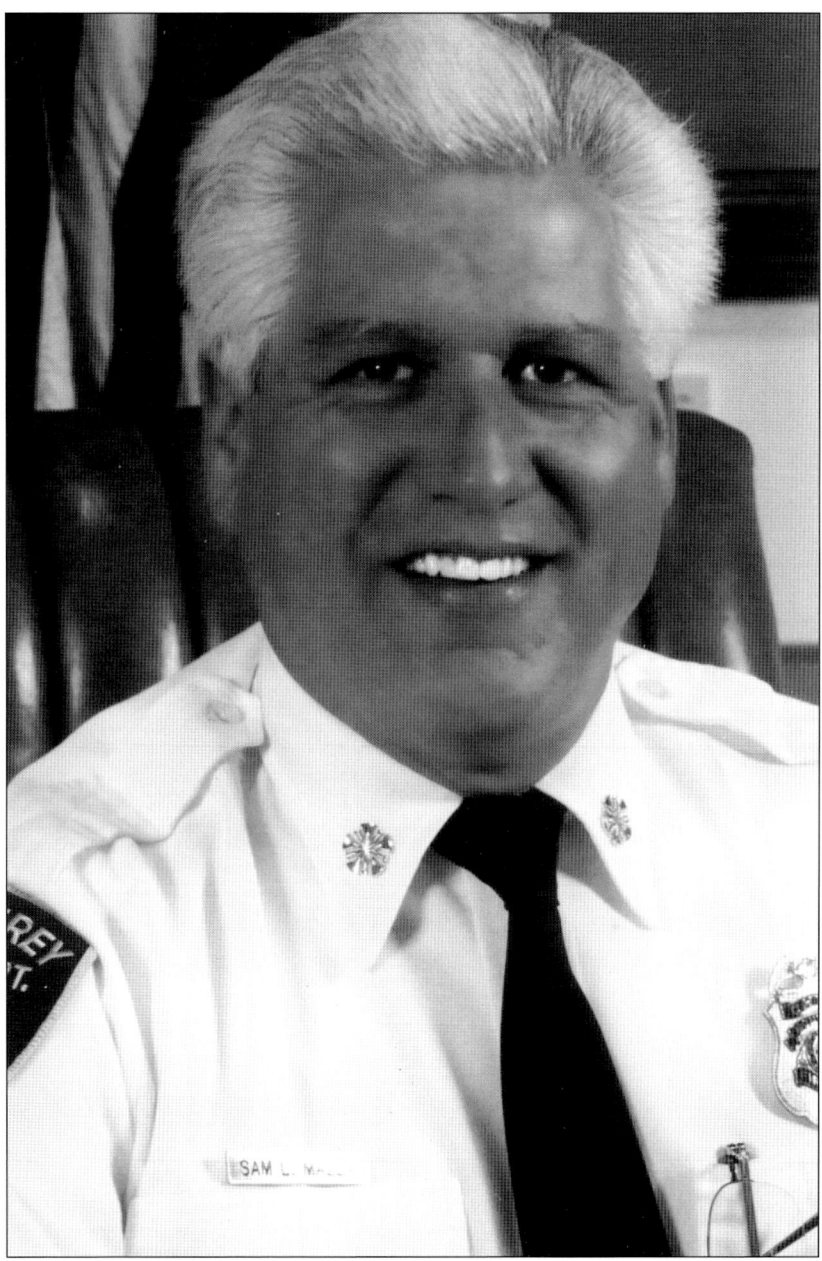

Sam Mazza was appointed chief of the department on February 13, 2006. He was formerly the chief of Monterey and San Benito County Ranger Units with California Fire. When hired, his mission was to pursue discussions with surrounding fire departments in hopes of forming a joint powers association in an effort to reduce the cost of fire service and the duplication of equipment in the local area. He spent numerous hours in meetings and working on the models that were needed to implement a joint powers association. Although the joint powers association did not take place, a merger did occur. Prior to his retirement in 2008, he accomplished the task of integrating Pacific Grove Fire Department into the Monterey Fire Department as the two departments merge their personnel. Chief Mazza retired on December 17, 2010. (Photographer unknown, courtesy of the Monterey Fire Department.)

Andrew Miller was promoted from assistant chief to chief on December 17, 2010, upon the retirement of Chief Mazza. Chief Miller was formerly the chief of the City of Pacific Grove prior to Pacific Grove Fire Department merging with Monterey Fire Department. Chief Miller has been tasked with the continuation of merging the local fire departments in an effort to reduce the cost of fire service. As other fire departments consider mergers, Chief Miller works closely with the firefighters' union to make sure there is a smooth transition. Chief Miller has an open door policy with everyone who comes to visit and talk; he holds an open forum called "Coffee with the Fire Chief." Once a month, on a rotating schedule, fire department personnel come together to discuss issues not related to personnel, and he provides information on issues related to the department business. (Photographer unknown, courtesy of the Monterey Fire Department.)

Two

FIRE STATIONS

Fire stations are a major component in a firefighter's service career. The station is a home away from home for many. As the fire service evolved over the years, so did the fire station or firehouse. The firehouse was first used to store fire apparatus, like hose carts, hose wagons, ladder wagons, and equipment. The volunteer firefighters of earlier times would respond to the firehouse to man the hose carts, hose wagons, and ladder wagons and pull them by hand to the fire's location. If they were fortunate, a brewery wagon would respond to the firehouse. The horses pulling the wagon would be hitched to the fire apparatus, and off they would go. The new firehouse that was constructed at 410 Main Street on April 1, 1911, included horse stalls; however, the department never purchased horses. As the fire service continued to evolve, the use of horses was phased out and mechanized fire apparatus replaced the hand-drawn apparatus. Monterey also replaced the volunteers with paid firefighters who spent the night in the station on a 24-hour shift schedule. The paid firefighters now needed home essentials, which called for sanitation, cooking facilities, and sleeping quarters. Beginning in 1882, the use of old storage barns served the firefighters. Fire stations replaced barn-type buildings to provide modern living facilities for the firefighters. The fire station not only provides living facilities but also storage, offices, and areas to park fire apparatus and equipment. This chapter identifies the fire stations and their locations at different periods in history.

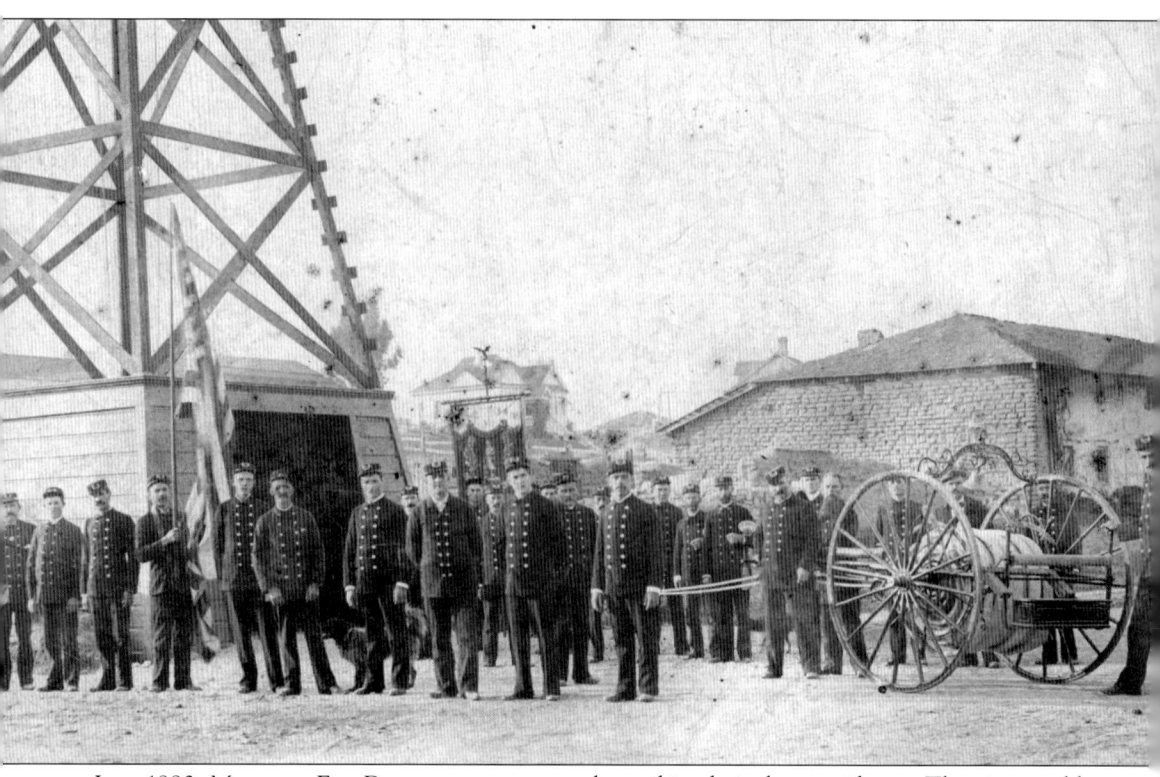

Late-1880s Monterey Fire Department personnel stand in their dress uniforms. The city would charter the department on March 4, 1890. Chief Parker is in the back row holding the command trumpet. This shed was located on Franklin Street at Main Street in 1905. The department would relocate to a barn located at 410 Main Street that year. To the left of the photograph is the shed that stored the hose cart and bell tower. The bell, when sounded, would summon the volunteers to the firehouse from various locations like home or work. The bell was a standard item in the early firehouses as a means of notifying volunteers. Striking the bell at different intervals would distinguish between fires, drills, and meetings. Two bells exist today, one in the courtyard of fire station No. 1 and the other in the lobby of the Elks lodge. (Photograph by Clara S. Parker, courtesy of the Monterey Fire Department.)

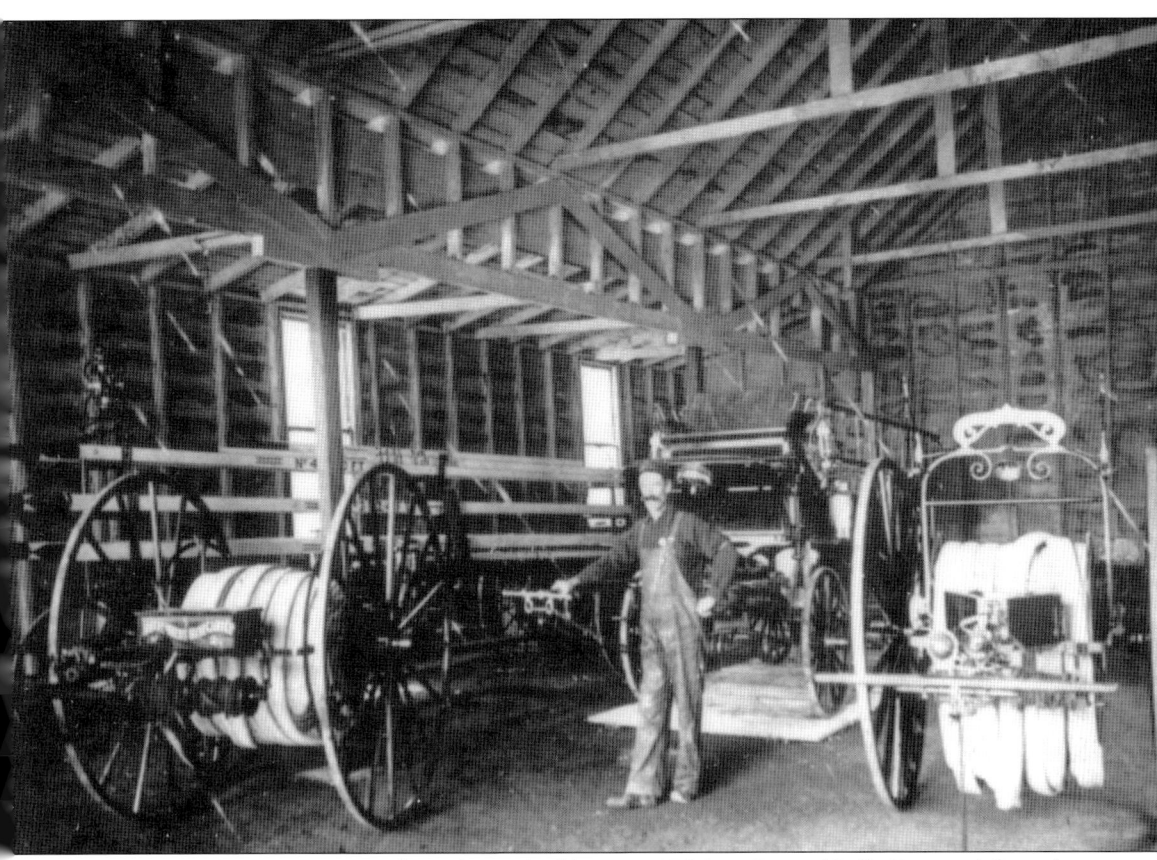

In 1905, the department moved to a larger building at 410 Main Street (Calle Principal Street); the new building housed the following apparatus under one roof: a ladder wagon, hose wagon, and two-hand hose carts. According to the Sanborn map of 1892, this location was an empty lot. The Sanborn map listed the independent hose cart as belonging to the fire department. The city water system consisted of 12 fire hydrants with an average pressure of 80 pounds. The 1905 Sanborn map shows a building on this site with the following fire apparatus: one combination hose wagon, one vintage hook and ladder, and one hose cart. The firehouse had a dirt floor, as seen in the picture. With the city unwilling to purchase the property, Chief Parker made payments himself of $90 per month. Several years later, the property was purchased by the city, and on April 1, 1911, construction of a modern fire station began.

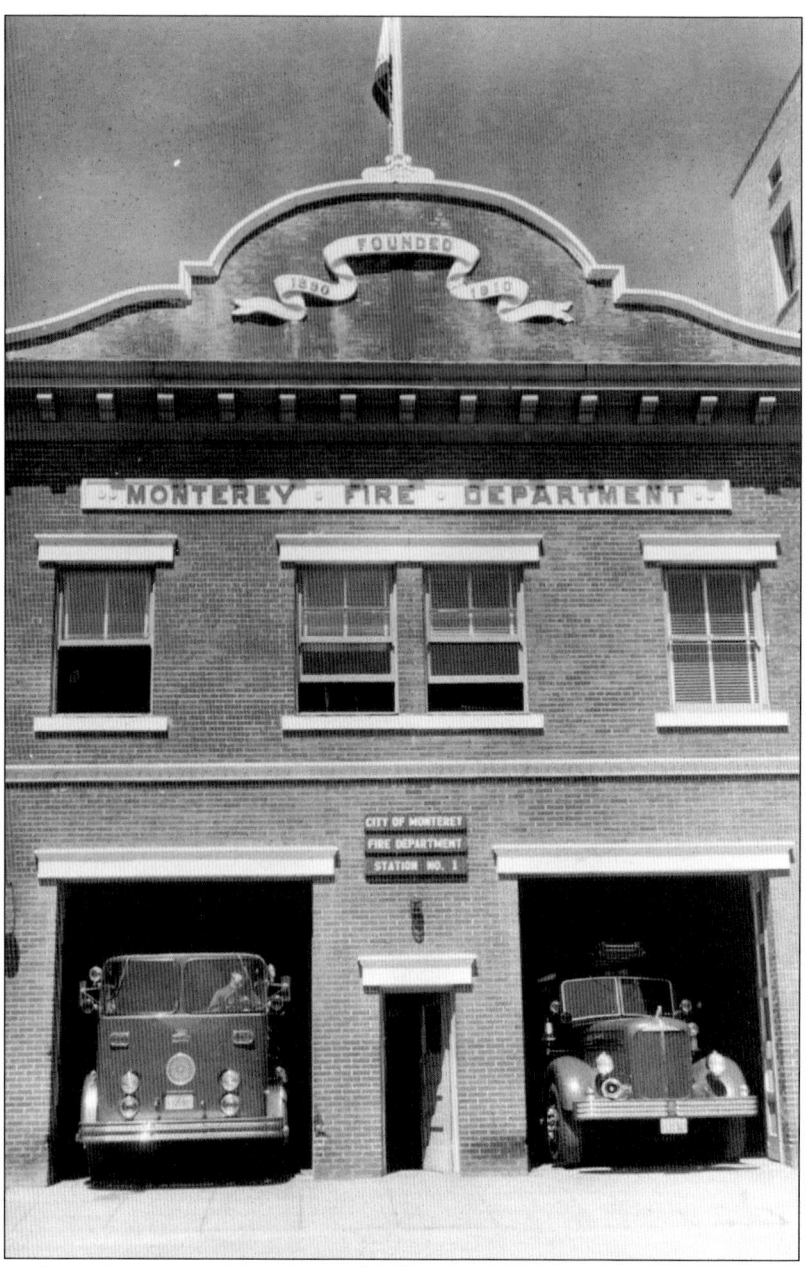

Fire station No. 1, located on Main Street (Calle Principal Street), was built on April 1, 1911. The old wooden building that previously was home to the hand-drawn fire apparatus was razed to build a new fire station. The cost of construction was $8,000; it was a cement building with a brick front. The lower floor was cement, and the fire apparatus was kept there; four stalls for horses were also built. There was a winding metal stairway that led to the upper floor. Also in the firehouse were a reception area, an office for the chief, and a dormitory with a bathroom equipped with showers, found at the rear of the chief's office. Two brass fire poles connected the upper floor to the lower, allowing firefighters to quickly reach the apparatus floor in emergencies. The fire station was eventually sold and has been home to several restaurants, the latest being Montrio Bistro.

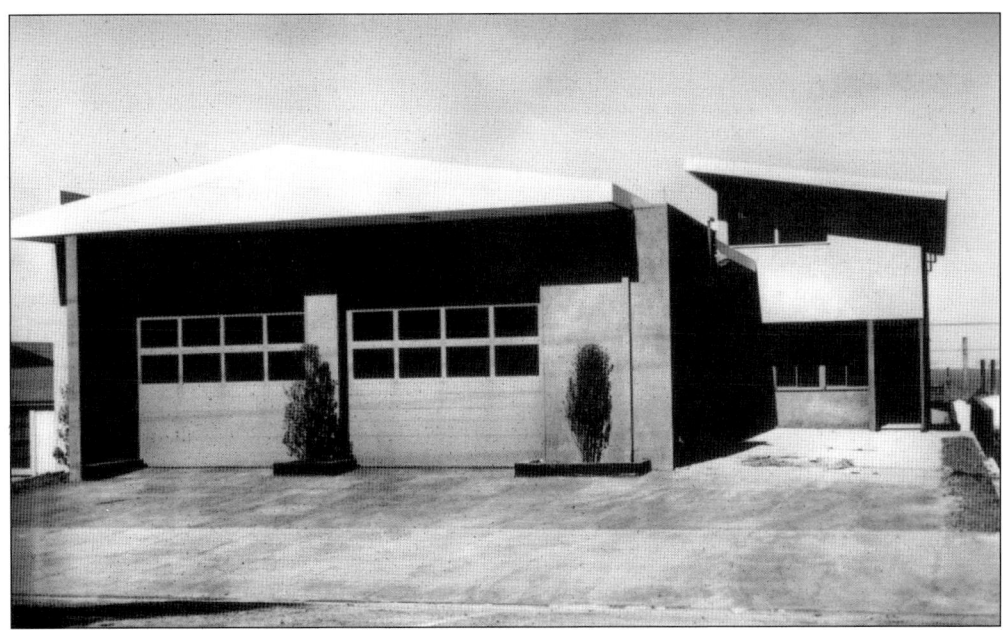

Fire station Nos. 2 and 3 were built at the same time through the passing of a bond measure on August 24, 1950. The Sanborn map of 1912 lists the location of fire station No. 2 at 518 Hawthorne Street, where it housed one hose cart. The 1950 fire station was built on or next to 1912 site. As the city grew eastward, fire station No. 3 was built at 401 Dela Vina Avenue in East Monterey in Del Monte Grove. The 1912 Sanborn map also located hose cart firehouse No. 4 at 1085 Fifth Street, which covered Oak Grove and East Monterey at that period in time. The cost of construction was $56,570 for station No. 2 and $65,527 for fire station No. 3. H.C. Geyer Construction was the contractor for both fire stations.

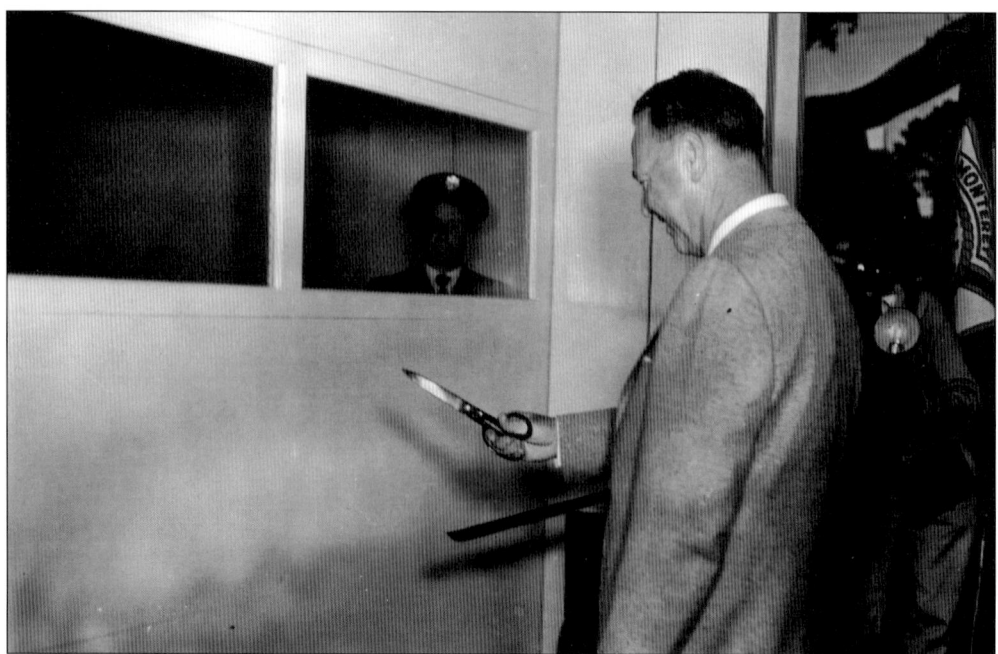

On April 10, 1959, Monterey mayor Dan Searle dedicates the new fire station by cutting the ribbon in front of the apparatus door. Firefighter Alfred Long can be seen in the window ready to push the button that operates the new electric doors. Known as El Curtel, the building housed city public safety services, which included its own dispatch center. The new public services building is located at the intersection of Pacific Street and Madison Street in the downtown area. Pictured below, citizens and city dignitaries are seated as the new public safety building is dedicated. This building housed the police and communications and headquarters for fire station No. 1.

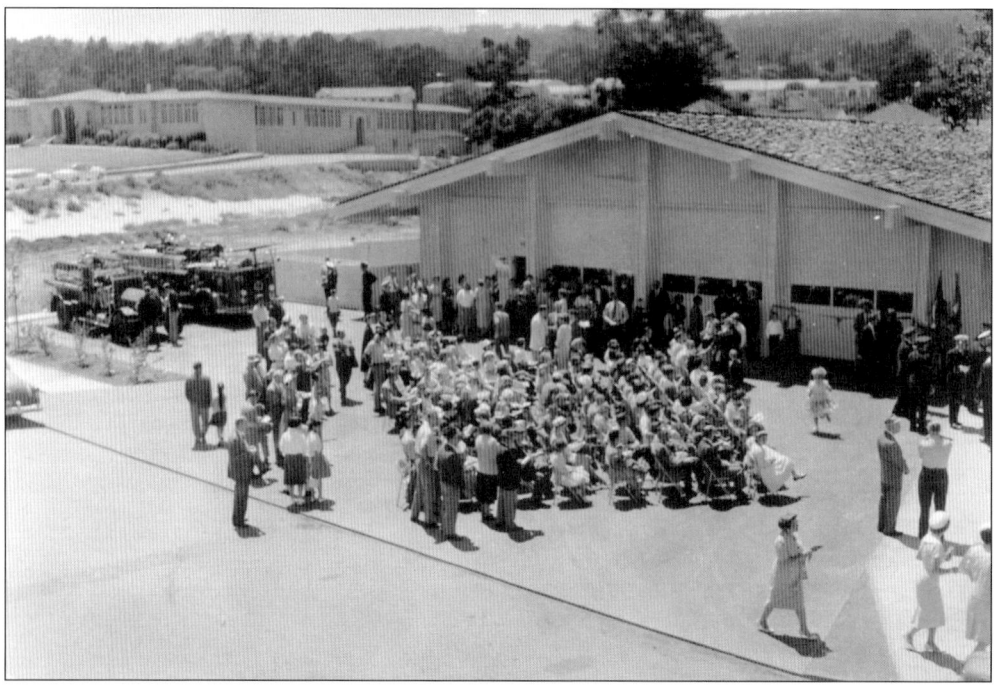

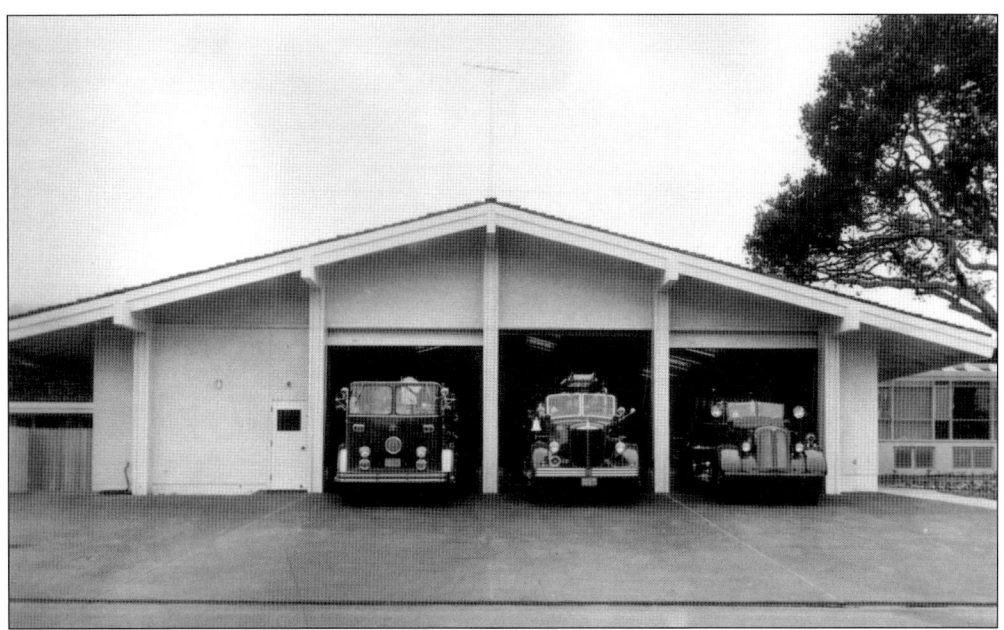

On August 1, 1959, a new fire station replaced the older station built in 1911 at 410 Calle Principal Street. From left to right are a 1956 Crown, a 1946 Mack, and a 1940s Seagrave aerial ladder. The front of the fire station included an apron to park apparatus and three overhead electric doors. The apparatus floor housed two fire engines and one aerial ladder. Below, an unidentified family peers into the dormitory-style sleeping quarters for firefighters on shift. Station officers had their own dormitory. As the fire department employed female firefighters and became an equal opportunity employer, the dormitory-style sleeping quarters were changed and divided into individual cubicles.

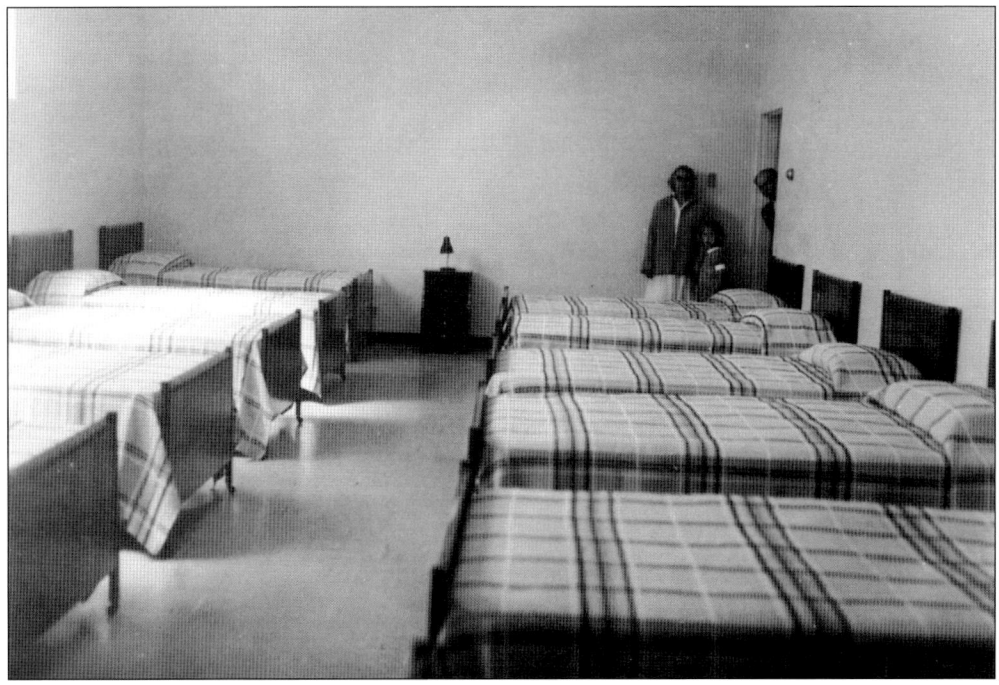

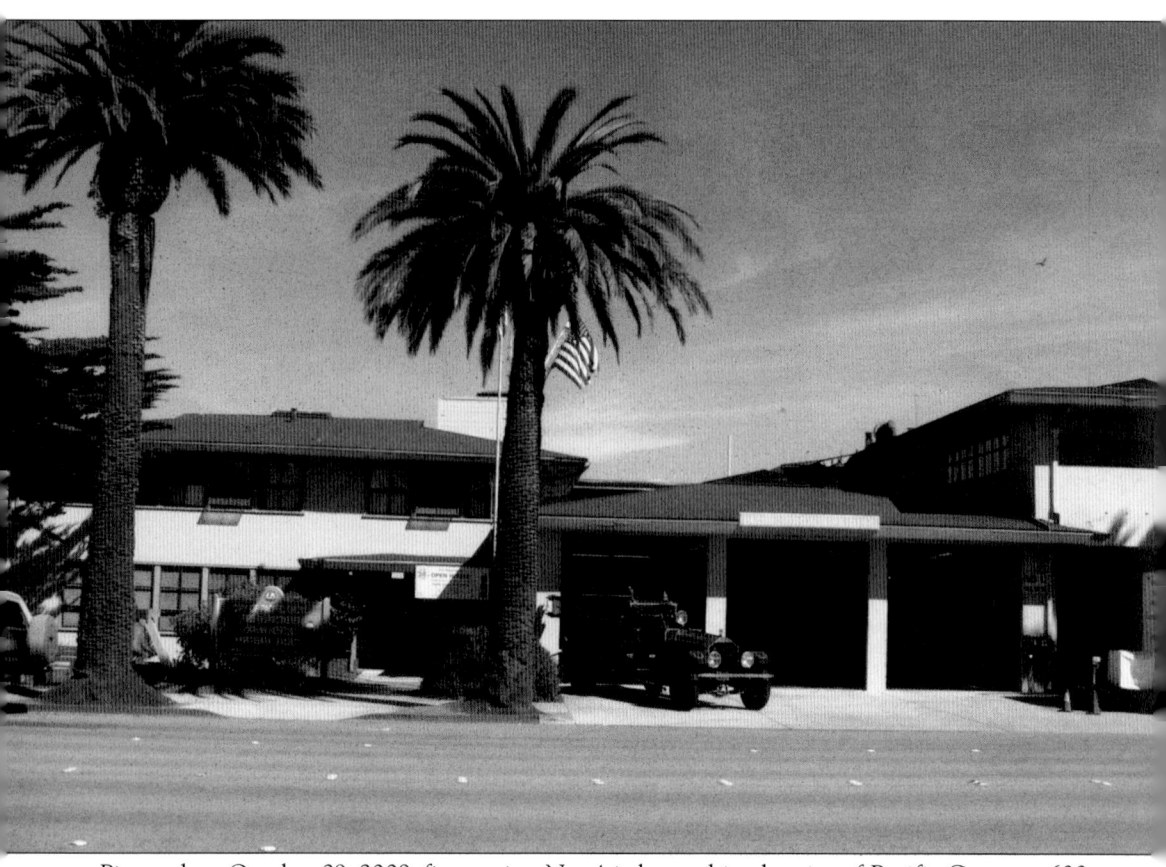

Pictured on October 29, 2009, fire station No. 4 is located in the city of Pacific Grove at 600 Pine Avenue. The fire station has been added onto over the years to allow for the physical fitness room, volunteers meeting room, and marine rescue and private ambulance company areas. The City of Pacific Grove maintains ownership of the fire station and all its fire apparatus, but the employees are members of the Monterey Fire Department, which provides service to the city under a contract. The fire station is also the home of a hyperbaric chamber and air compressor, which are used for treating scuba divers who suffer water accidents, like the bends and air embolisms. The Pacific Grove Marine Rescue Unit is located at this fire station and is manned by trained volunteer scuba divers who respond to water accidents. (Courtesy of the author.)

Three

FAMOUS CANNERY ROW FIRES

On October 6, 1924, the Hovden's Reduction Plant, owned by the Great Western Packing Company, caught fire. The alarm was received at 7:30 p.m., and the fire was brought under control by 8:30 p.m. No one knew at the time that these fires would plague the Monterey Fire Department for the next four decades. The fishing industry would expand over the next 30 years as Monterey became the sardine capital of the world. At its height, Cannery Row was home to 19 operating canneries. These canneries continued to operate until the sardines slowly disappeared. Once the fishing industry died, the vacant canneries became the home of other industries, like the National Automotive Fibers Corporation, who occupied the old San Carlos Cannery. A cannery fire was a firefighter's nightmare, as the fire was usually only accessible from the front along Cannery Row, making firefighting extremely difficult. From years of canning, the floors of the canneries were impregnated with fish oil, and fish meal was ground into the timbers, and so the buildings would be totally engulfed in flames in a matter of minutes. As the fishing industry diminished, the economy of the city was weakened. The city turned toward revitalization of the Cannery Row area for tourism. Developers were interested in developing Cannery Row as a destination spot for tourists featuring fine dining and hotels. The old canneries stood in the way, and the cost of demolishing the buildings was expensive. Old canneries began to burn at an unusual rate—sometimes several in a three-month period. These fires would tax the fire department and its firefighters. Large flames generated from these fires dwarfed firefighters. The firefighters learned from their experiences and began to pull resources from the surrounding cities and developed agreements to give mutual aid to each other when these fires occurred. There were numerous fires on Cannery Row, and the following chapter captures some of the more dramatic ones.

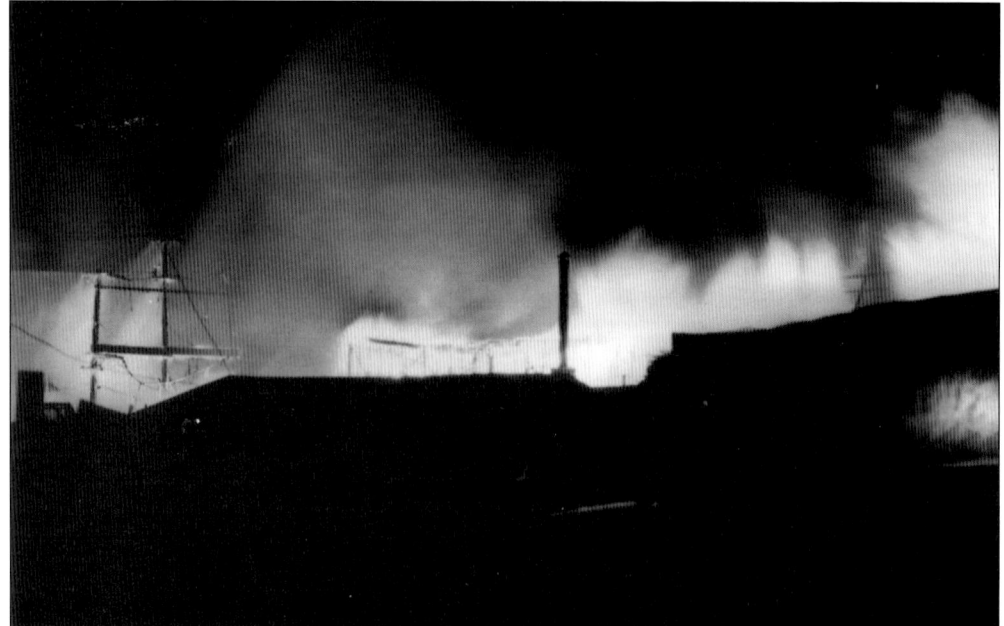

On November 24, 1936, fire struck the Del Mar Canning Company; the buildings involved consisted of the Old Bayside Fish and Flour Plant Company reduction plant, built about 1917; Sardine Products Company, built in 1929; two warehouses; and the Cypress Fisheries reduction plant. As the fire roared out of control, there was an ominous glow in the sky that night. Pictured below, flames and smoke fill the night sky as onlookers stand off in the distance feeling the heat of the fire as it spreads from building to building. The Del Mar Canning Company fire was the most disastrous since 1924, which was when the Associated Oil tank farm was struck by lightning on September 14 and burned for 72 hours.

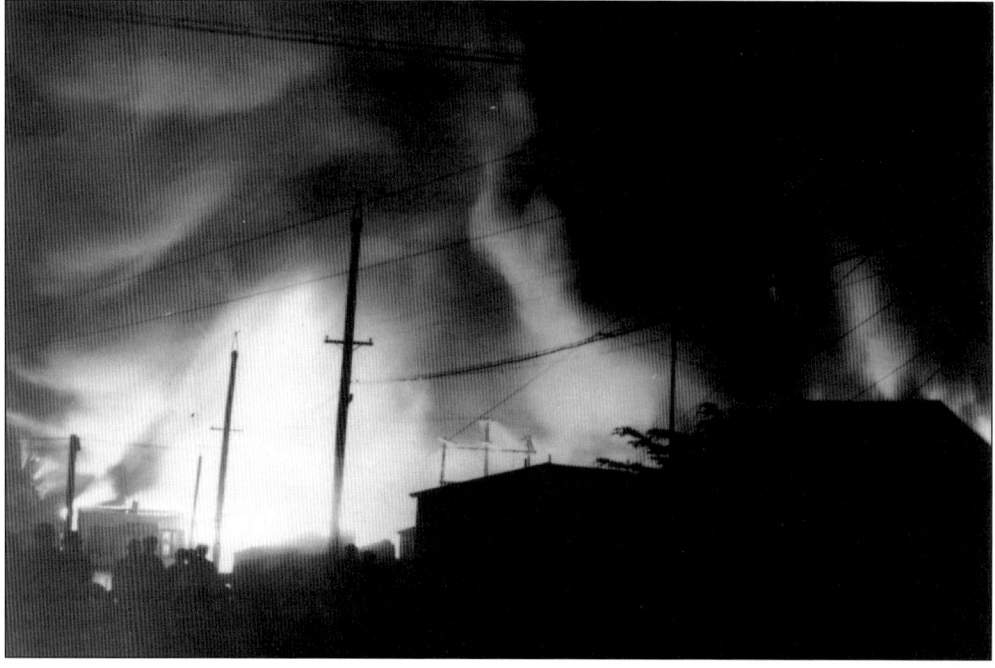

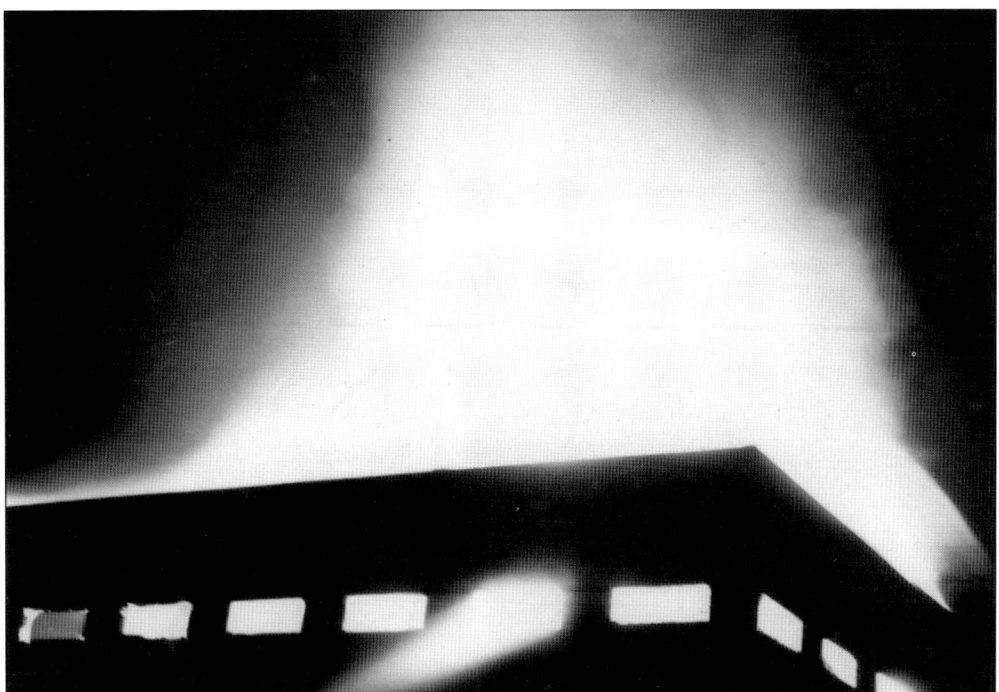

The Del Mar Canning Company fire loss was set at $750,000, and approximately 100 firefighters fought the fire using 5,000 feet of fire hose. Fire departments from the cities of Monterey, Pacific Grove, Carmel, and Salinas kept the fire from spreading beyond the buildings that were already involved. Water applied by fire hoses has little effect on large fires, as the water evaporates due to the heat from the fire. Pictured at right is the building the day after the fire. What remains are pallets of canned fish stored in the warehouses that were destroyed by the fire. The fire apparently started on the second floor of the Del Mar Canning Company at the reduction plant above the boiler room. Workmen on duty were unsuccessful in using chemicals from a plant hose line in an effort to quench the flames.

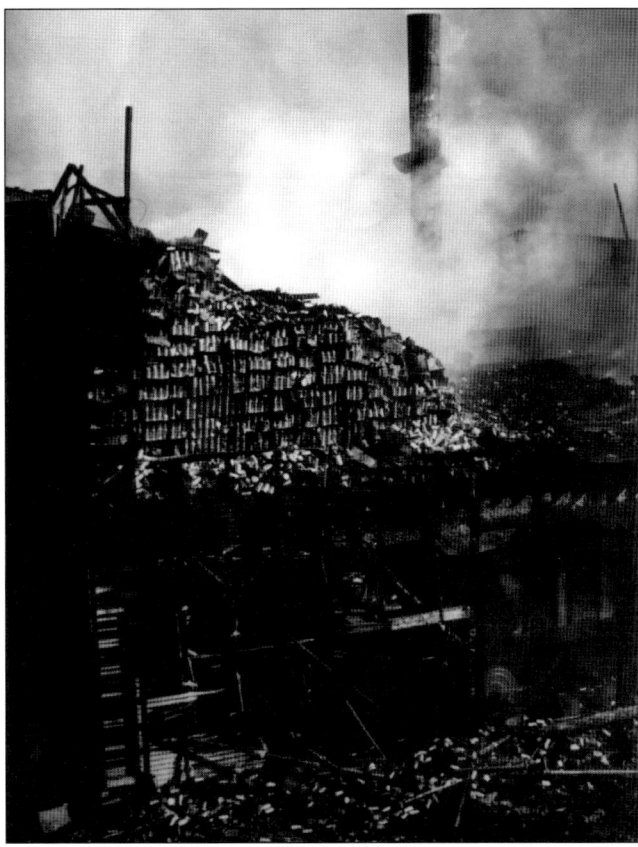

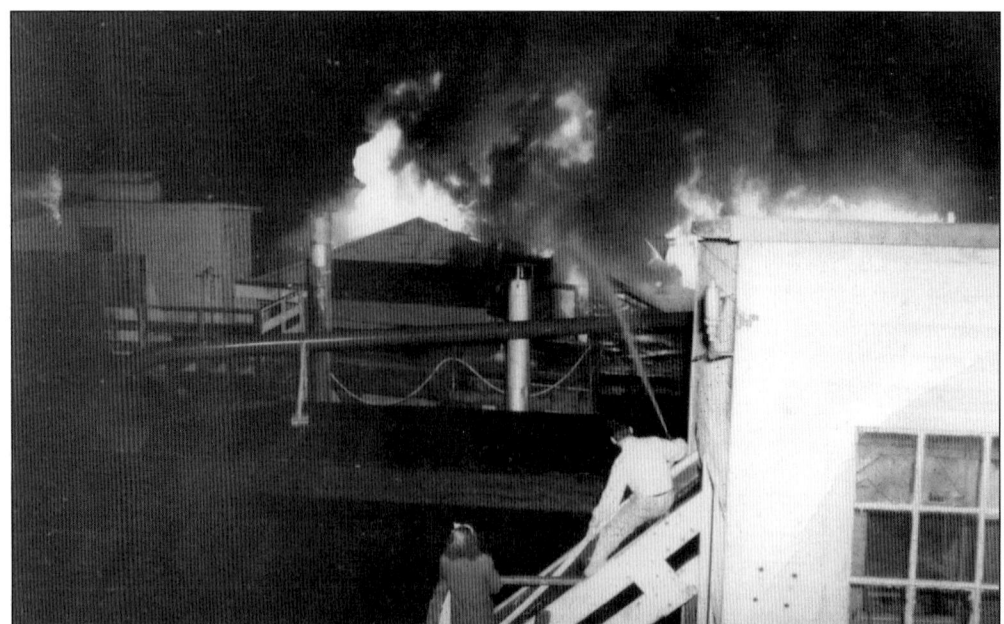

On October 21, 1948, California Packing Corporation and Carmel Canning Company burned for nearly two hours prior to firefighters gaining control of the fast moving fire. Two unidentified citizens put water on embers near their home to protect it from the fire. The blaze was reported at 9:15 p.m. The fire involved both military and peninsula departments. It was estimated that 370,000 gallons of water were use to control the fire. The fire drew a crowd of nearly 2,000 spectators. Below, the fire can be seen to the rear of the processing plant and conveyor system, with the flames rolling along the ceiling. Reports state that the fire seemed to have started in the California Packing Corporation cafeteria and then jumped with lighting speed into the Carmel plant, where the majority of the fire damage was located.

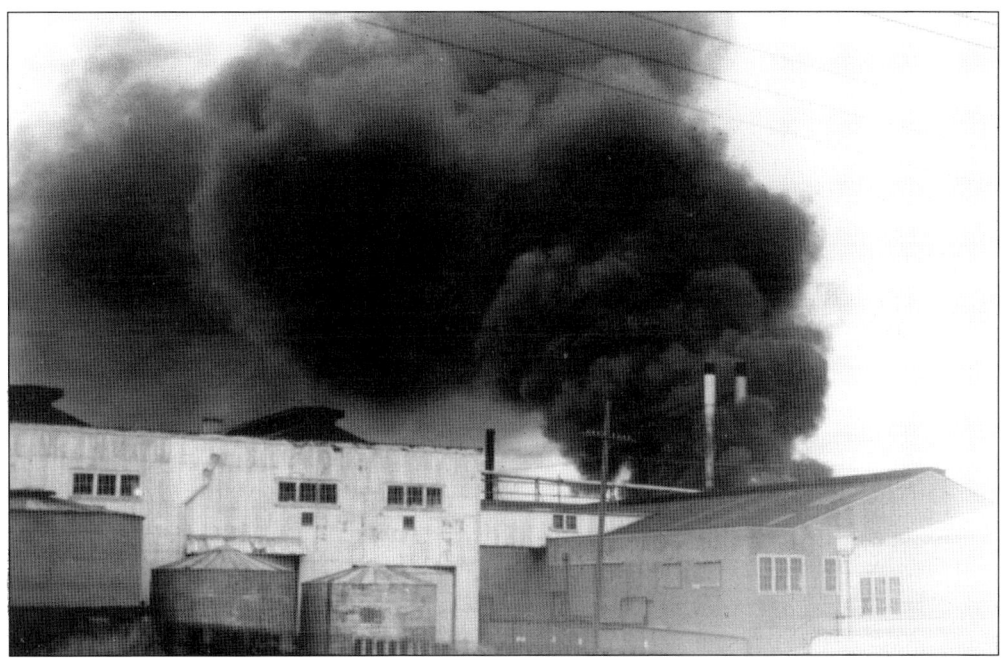

Westgate–Sun Harbor Company caught fire on December 8, 1951; the cannery ignited two warehouses in the early morning hours, causing an estimated $1.8 million in damage. Firefighters fought the fire for two and a half hours, placing thousands of gallons of water onto the fire. Although the fire consumed the warehouse, the firefighters were able to keep the three tanks containing fish oil next to the burning building from catching fire. Firefighters from eight departments were used to control the blaze. Pictured below, the fire spreads from the packinghouse to the warehouses, taxing firefighting resources. The warehouses contained fish that had already been processed and was awaiting shipping and cardboard boxes and wood pallets that were stacked almost to the ceiling.

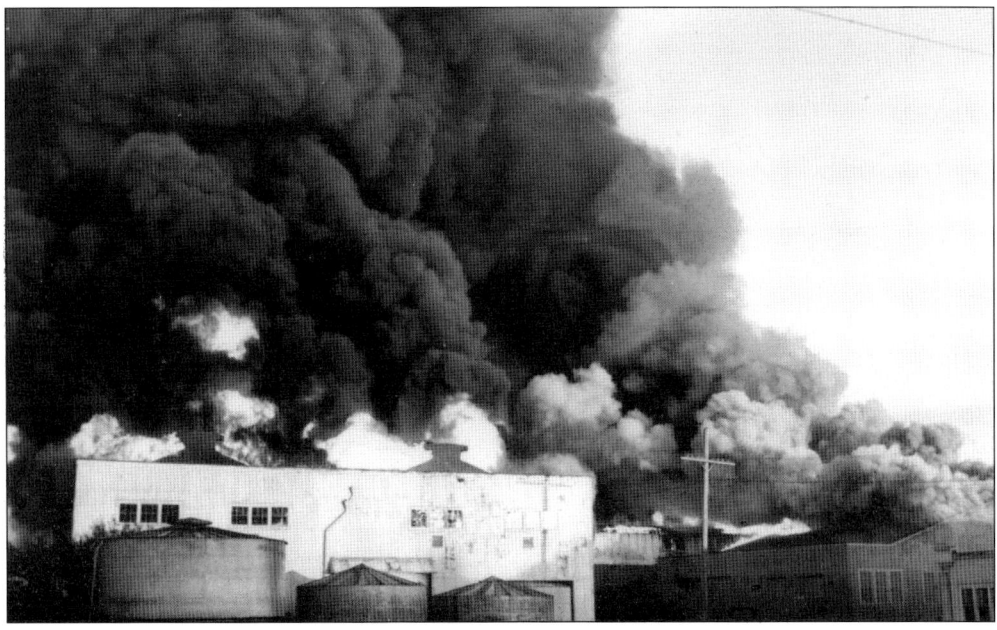

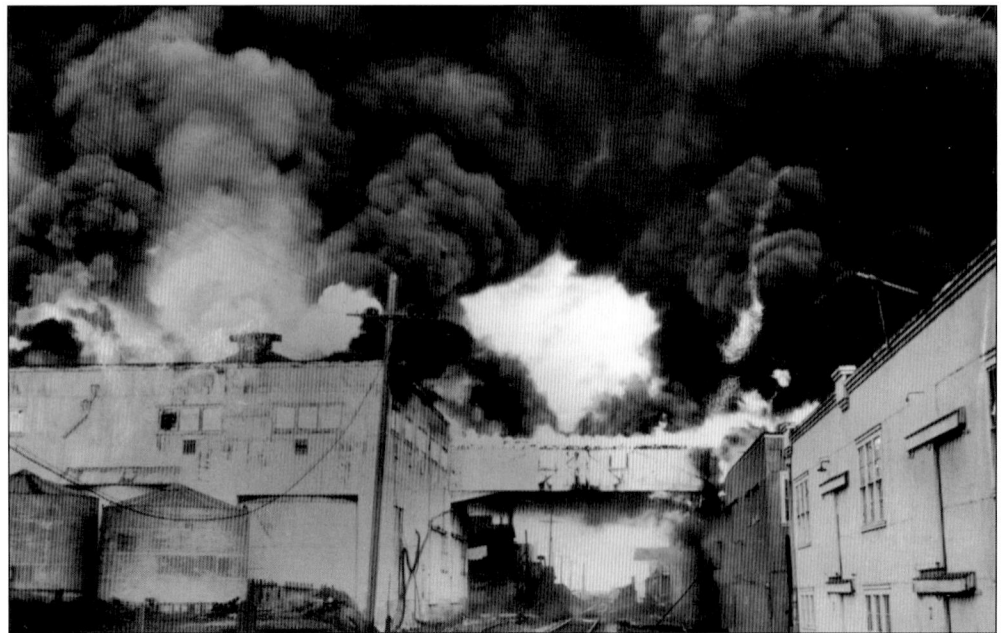

The Westgate–Sun Harbor Company overpass was used to take the processed fish in cans and store them in the warehouse. These overpasses play an important part in fire spreading from one building to another. The overpasses were unprotected, meaning they had no fire sprinklers, and once fire started in one of the buildings, heat was transmitted to the other building, igniting the contents stored inside. Below, firefighters are dwarfed by the size of the buildings, and often, the buildings were fully involved by the fire upon their arrival. This building was wood frame with corrugated metal siding that would retain the heat, which intensified the fire.

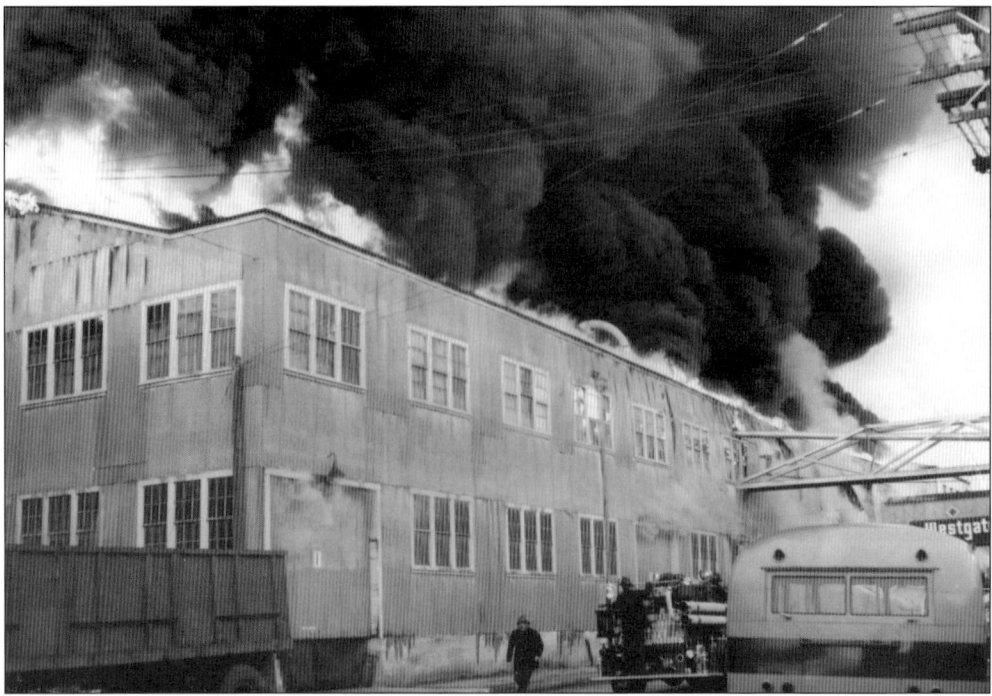

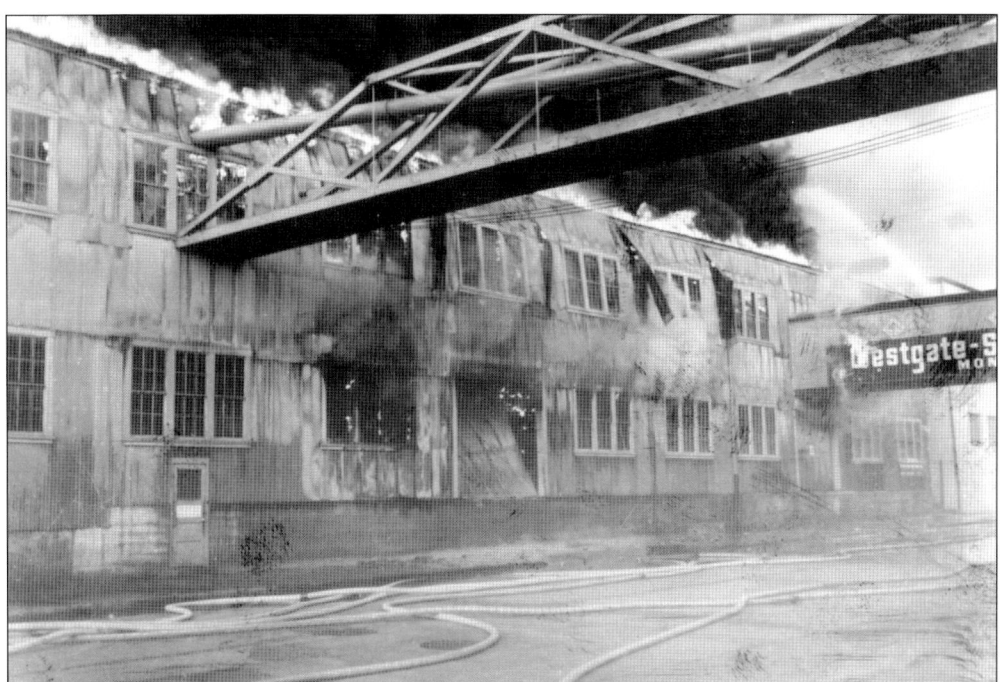

Above, Westgate–Sun Harbor Company's corrugated metal siding begins to buckle under the heat, and the fire is burning away the exposed wood structure holding the siding. The picture at right shows the fire damage done to the many pallets of fish. Individuals are seen salvaging cans of fish after the fire. Westgate–Sun Harbor Company was involved in three major fires: in 1950, a $50,000 loss; in 1951, a $1.8 million loss (pictured); and in 1952, a $1.5 million loss. In the 1950 fire, fire chief Gregory Teaby would go on the record and state that firefighting was hampered by the lack of an aerial ladder truck. The 35-foot ladders were three feet short of reaching the top of the canneries.

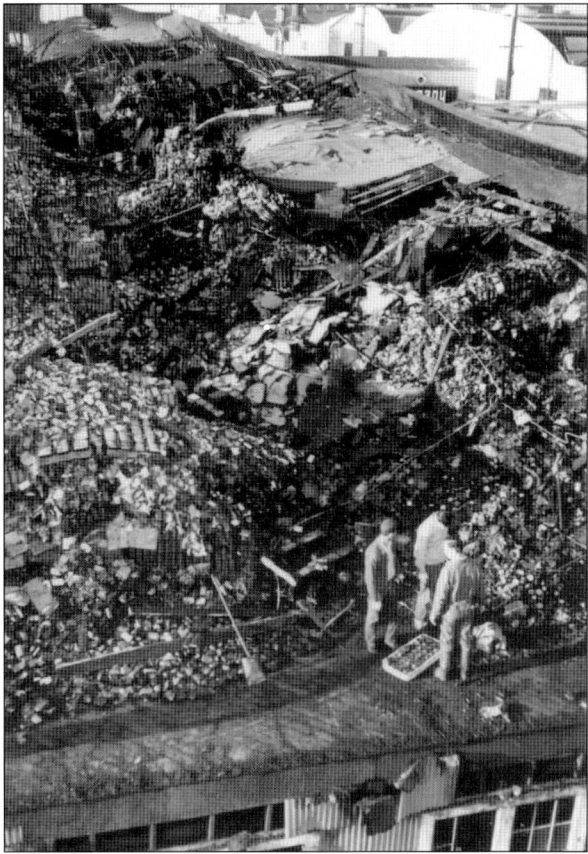

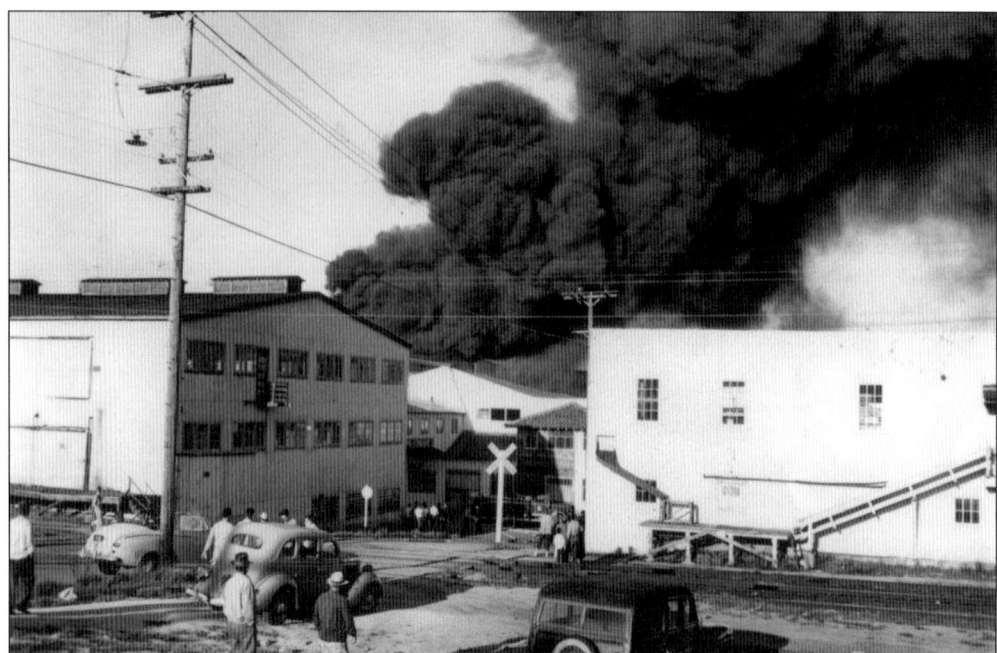

On October 24, 1953, the Sea Beach Canning and Custom House Packing Corporation burned, shooting flames more than 100 feet into the air. The alarm came in at 3:48 p.m. from the automatic system located at Sea Beach and was followed up by the pulling of a fire alarm box in the street. Below, firefighter Leonard Saia (left) and an unidentified firefighter drag hose lines across the rooftop of an adjacent cannery in hopes of getting water into the burning cannery to aid in extinguishing the fire. The lack of an aerial ladder limited the firefighters' ability to place water on the fire and often placed them in dangerous situations. Smoke from the cannery was visible for over 20 miles and drew a crowd of about 3,000 spectators.

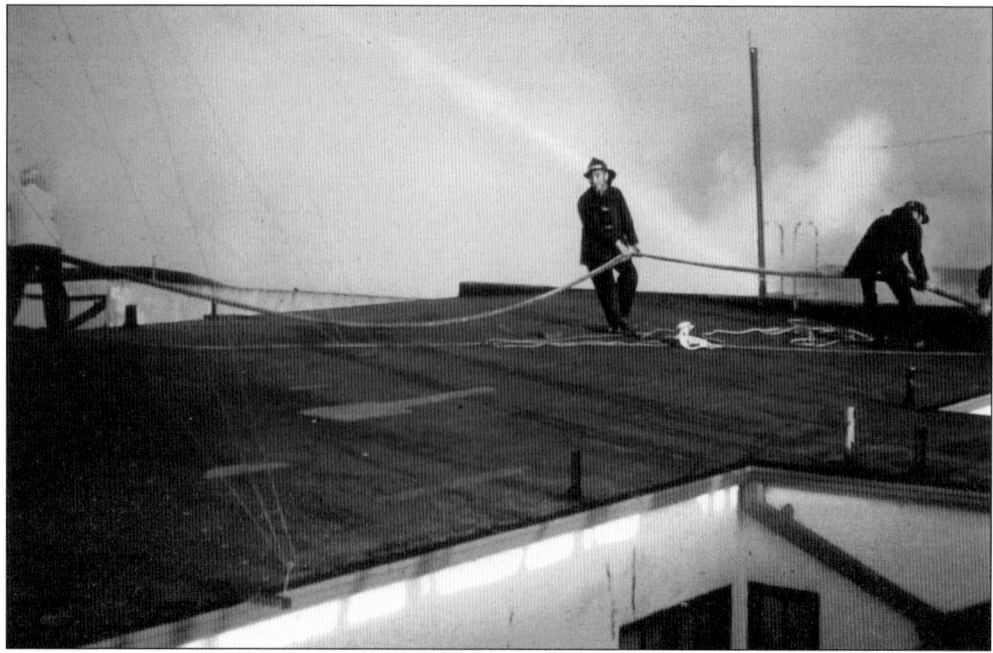

The Sea Beach Canning and Custom House Packing Corporation fire started in the upstairs warehouse. Approximately 110 firefighters, including a Navy detachment, helped bring the fire under control. The fire roared from the front to the rear of the building, equaling some 200 feet, in just minutes. Pictured below, the fireboat was credited with keeping the pilings under the cannery from burning, placing about 1,800 gallons of water per minute on the fire. The boat had to retreat when the tide started going out. The fireboat being effective as in this incident was not always the case, and the boat would often have to abandon its firefighting effort due to low tides or mechanical breakdowns.

On November 22, 1956, the old San Carlos Canning Company, which housed a branch of the National Automotive Fibers Company, caught fire and burned. The fire sent a column of smoke into the air that could be seen as far away as Santa Cruz and Watsonville. Since the flames spread so fast, the firemen said they never had a chance of saving the old building. Four men were inside the building when the fire erupted, and all four got out of the building alive. A four-inch gas main providing gas to the plant continued to burn inside the plant for four hours until it could be shut off.

The old San Carlos Cannery was located next to the Coast Guard pier. It was the largest cannery on Cannery Row and was in excellent condition. The National Automotive Fibers Company plant employed approximately 230, who were put out of work due to the fire. The fast spread of the fire was attributed to the large amounts of cloth, plastic materials, flammable glue, and rubber cement used in the lamination process. The plant manufactured door panels, armrests, and other interior trims for automobiles. Below, engineer Robert Greathouse, in turnout clothing, works with citizens who lend a hand in manning a hose stream.

At the height of the San Carlos Cannery fire, over 250 firefighters were on the fire to keep it from spreading. The aerial ladder truck came close to being buried when the wall of the building collapsed. Later, the top rungs of the aerial ladder were burned off when the ladder was shoved through a window of the burning cannery. The fire loss was estimated at $2 million. Pictured at left on June 17, 1967, the Enterprise Cannery erupts in fire. The cause of the fire was suspicious. The flames reflect off the waters of Monterey Bay as the fire burns out of control.

The Enterprise Cannery overpass collapsed, and three firefighters suffered minor injuries when they were inside trying to keep the fire from spreading from the cannery to the warehouse. Firefighters applied water through windows, but it had little effect as the fire continued to burn on the ocean side of the cannery. Below, a fire engine from Pacific Grove with an unidentified off-duty firefighter applies water on the cannery with the use of the engine turret. Ladders alongside the front of the cannery were used to direct water. Most cannery fires could only be fought from the front of the building, as there was no access to the back or sides of the building.

On October 10, 1967, San Xavier Cannery goes up in flames, making it the second cannery to burn that year. The fire was suspicious. The San Diego Fire Department later arrested an individual for arson in the city who claimed to have started at least three cannery fires in Monterey. He called himself the Green Ranger. The fire occurred at the beginning of Fire Prevention Week and was discovered at 7:35 p.m. Flames were visible all around Monterey Bay. Below, the fire burns out of control, ripping through the abandon cannery. The wood flooring was saturated with years of fish oil, which caused the rapid spread of the fire.

The San Xavier Cannery, seen from a distance above, is engulfed in flames, and the metal siding is falling away. Abandon cars adjacent to the cannery were hidden from the view of the public. These areas were not visible from the street. Many owners of canneries used these vacant lots as dumping grounds. Pictured below are the remains of the San Xavier Cannery after the fire. Most of the canneries were 150 to 200 feet deep from the front of the street. Hose streams were most effective when the fire approached the street. It was determined the fire started 40 to 50 feet from the front of the building on the main floor, where acetylene torches were being used to dismantle boilers.

On December 25, 1967, Christmas Day, Carmel Canning Company erupts in fire. This would be the third cannery fire since June of that year. This point in time is when Cannery Row was undergoing redevelopment to make way for restaurants and hotels. Below, spectators watch the fire as thick black smoke rises into the blue skies above Cannery Row. The aerial ladder fire stream has little effect on the fire. The unidentified firefighter on the aerial ladder turns his body to avoid the heat and keep from inhaling smoke from the fire.

As spectators watch, Carmel Cannery is fully involved. This side of the cannery was constructed of concrete, unlike most of the other canneries. The vacant lot is from a previous cannery that burned some time earlier. The concrete footings can be seen below the concrete wall of the burning cannery. At right, spectators are leaving the area. The fire burns out of control as the aerial ladder fire stream has little effect on the fire. In the foreground is an overpass that leads from the cannery to the warehouse, constructed of wood. With no built-in fire protection, the overpass provides an avenue for fire.

45

The Carmel Cannery fire was held to the processing plant. Ocean-side firefighters kept it from spreading to the warehouse. The warehouse in the foreground was also saved from a previous fire; the overpass opening is sealed off. Above, Monterey Fire Department's aerial ladder is used to apply water to the warehouse to keep embers from catching the roof on fire. The estimated fire loss was $250,000. About 65 firefighters from Monterey, Pacific Grove, and Seaside, along with volunteers from Carmel, Carmel Valley, and Marina, fought the fire. The fire was labeled suspicious and arson was suspected, as it was the third fire in seven months on Cannery Row. Pictured below is the new Cannery Row as it is today, with hotels and gourmet dining establishments and the Monterey Bay Aquarium. (Below, courtesy of the author.)

Four
Large Commercial and Residential Fires

As the story goes, the fire bell rung for the first time on September 30, 1894. The fire was in New Monterey at the Last Chance Saloon. It was one of the first commercial fires to be experienced by the newly chartered fire department. The fire had all but devoured the whole building and the outhouses, so the department turned its attention to saving the house next door. Since the fire companies did not have horses, they used brewery horses that pulled drays (heavy carts) to aid them in pulling fire apparatus. When the alarm sounded, a teamster would head for his company house, beer wagon and all. He would hitch his team to the hose wagon and off they would go. A few mishaps were recorded—for instance, sometimes the hook and ladder crew would race to the fire only to find that the hose cart or hose wagon had not arrived. The men would watch the fire or aid in the bucket brigade until the others arrived. Once, there was a reported fire in New Monterey, and the hose wagon boys commandeered the old Presidio Trolley and hitched the wagon to the rear end. The trolley rounded a sharp turn, and the hose wagon tagging behind took off the ground and spun over in midair, dumping its contents over the countryside. There was so much hose that it looked like somebody spilled a large plate of spaghetti, as remembered by Harry Shaw, the fire department's first paid fire engineer. The Associated Oil tank fire involved six oil tanks containing 55,000 gallons each of crude oil and three 200,000-gallon tanks of refined gasoline, along with smaller tanks of kerosene. This fire consumed two canneries, five homes, and six fishing boats moored in the bay; the fire also took the lives of two soldiers.

On July 8, 1893, the clanging of fire bells and the blast from the whistles operated by the electric light company were heard about 10:00 p.m., sounding the alarm that Monterey's new schoolhouse was on fire. There was little doubt that the fire was intentional in origin, as the smell of kerosene, which had been strewn about the balcony where the fire had started, was still lingering. Motive for the fire was contributed to the fact that the school trustees were about to discharge a number of older teachers and engage new teachers at the opening of school. Pictured at left on Sunday, September 14, 1924, at 10:10 a.m., fire alarm box No. 45 was turned in as lighting strikes the Associated Oil tank farm, located at Presidio Curve near Cannery Row; it would burn for three days. (Above, from *Historic Monterey Surroundings* by Wallace Clarence Brown, courtesy of the Monterey Fire Department.)

On September 14, 1924, the Associated Oil tank fire boils over, spreading fire and oil into the ocean along Spence Street at Lighthouse Avenue. The 1916 Seagrave pumped water on the fire for 72 hours, never shutting down; it continued to pump water even when it was being refueled. Earning the nickname "the Old Gray Mare," the engine worked as hard as a horse. Two soldiers lost their lives while fighting the fire. Pictured below on September 24, 1924, the Hotel Del Monte's main building burned down. Embers from the chimney landed on the roof of the building, causing the fire. Tents were used for registration, and the hotel remained open while under construction. The main building was reopened in 1926. (Right, photographer unknown, courtesy of the Monterey Fire Department; below, courtesy of Monterey Public Library's California History Room and Graham family [Terry L. and Barbara Briggs-Anderson].)

On October 20, 1930, a fire swept through the historic Del Monte Bathhouse, which in the 1880s and 1890s catered to California's social elite. The fire, of undetermined origin, broke out at 10:30 p.m. at the bathhouse, which was nestled among the sand dunes just above the Del Monte Hotel. Firefighters were able to keep the fire from spreading to the nearby dance hall, buildings, and pier. The cause of the fire was contributed to faulty wiring or a carelessly discarded cigarette. (Courtesy of the Monterey Fire Department.)

Minick's Warehouse, located on Del Monte Avenue, was destroyed by fire on May 26, 1940. Fire engines responded from station No. 1, as fire station No. 3 had not yet been built. At this time, however, fire mains with hydrants were installed along Del Monte Avenue.

A fire on March 26, 1953, destroyed the Ramsey Motor Company at 409 Tyler Street as a spark causing the blaze touched off a gasoline tank being drained into a bucket. Pictured are, from left to right, Capt. Harry Shaw, two unidentified civilians, assistant chief Clifford Hebrard, and firefighter Donald Cavin. At right, an unidentified firefighter on an aerial ladder is directing the hose stream through the roof into the building.

Shown at Ramsey Motor Company are, from left to right, an unidentified mail carrier, unidentified off-duty firefighter on the roof, unidentified firefighter in civilian clothing, firefighter Ward Chant, off-duty firefighter Jack Sprowls (in civilian clothing), fire captain Harry Shaw with a white shield on his helmet, unidentified, firefighter Donald Cavin, and unidentified. Approximately 18 cars were destroyed in the blaze at a cost of over $50,000. It was estimated that the loss to the building was over $200,000. Pictured below are, from left to right, an unidentified off-duty firefighter in civilian clothing, unidentified firefighter in turnout clothing, fire captain Harry Shaw in the middle with the black and white helmet, and an unidentified firefighter. They are applying a hose stream to the interior of the building. Standing next to ladder on the fire engine is an unidentified firefighter.

On September 14, 1953, fire struck Walter Colton School. Since it was the second fire in two months, it was determined to be arson; also, signs of vandalism in the home economics building were found. The school suffered a fire loss of $97,000. Two 13-year-old boys were later arrested for setting the fires at the school. On April 29, 1955, fire erupted in a warehouse located on Wave Street just above Cannery Row. Below, firefighter William Ives (with the hose line) and unidentified civilians are helping to extinguish the fire.

On August 3, 1957, fire erupts at a residence on Huston Street with a crowd of people looking on. By the arrival of the fire department, the residence was completely engulfed in flames. The residence was located across the street from the Sherman Rose Inn and one building up from the historic house that once belonged to author Robert Louis Stevenson. Pictured below on March 29, 1959, fire rips through the kitchen of Angelo's Restaurant, located on Fisherman's Wharf. The fire department received the call at approximately 4:00 p.m. The caller saw fire coming through the second floor of the restaurant. The fire was attributed to electrical causes, but the case was reopened when an attempt at arson was found under Tarritino's Sea Food. A wharf piling had been doused with kerosene and ignited.

On March 29, 1959, fire destroyed the interior of the kitchen at Angelo's Restaurant on Fisherman's Wharf. Pictured below on December 15, 1959, Wharf Theater, located on Fisherman's Wharf, was gutted by fire. The musical *Oklahoma* was scheduled to play. The fire was contained to the theater, and no damage was reported to adjacent buildings. The fire loss was estimated to be $75,000. The fireboat *William E. Parker* arrived on the scene, but the sea surge was too much for the fireboat. The fireboat was thrown into reverse as it neared the burning building, but not in time to prevent it from ramming into the pier and caving in one of the pilings under the building. Firefighters then ordered the gallant little fireboat to retreat without applying water.

Pictured on December 15, 1959, are, from left to right, an unidentified firefighter, off-duty firefighter Lee Harter with a self-contained breathing apparatus, and an unidentified firefighter. This was a time prior to federal and state standards, and firefighters often responded in civilian clothing to fight fires. Pictured below on January 27, 1960, firefighters respond to the bowling alley for a roof fire. Off-duty firefighter Claude Costa (left) in civilian clothing talks to unidentified firefighter. The bowling alley was located behind the Professional Building, which was next to the old fire station on Calle Principal Street. The bowling alley was razed for a new building for the Monterey Institute of Foreign Studies.

Monterey Fire Department is called to mutual aid by the City of Seaside to help in the extinguishment of the H&H Lumber Company fire on April 19, 1961. The lumber company was located just over the city limit line from Monterey. The automotive wrecking yards in the foreground along Del Monte Avenue have been rezoned for a Holiday Inn and M&S Lumber Company. The fire was reported at 7:00 a.m. and was Seaside's largest fire since the loss of the Del Rey Theater on June 23, 1947. Pictured below, the lumberyard, located off Canyon Del Rey, is completely involved in fire. The H&H Lumberyard site now is the location of Chill's Restaurant and a parking lot for an Embassy Suites.

On May 5, 1966, firefighters were called out at 3:42 p.m. to the Hotel San Carlos Coffee Shop. The aerial ladder truck was used to gain access to the roof. A fire in the kitchen flue, found above the cooking line, ignited grease and spread to the roof. Pictured below on April 18, 1969, patrons of Oberg's Nightclub flee for their lives. Reported a little after 1:00 a.m., the fire was an act of arson. A patron was ejected from the nightclub and returned with a one-gallon glass container of gasoline and tossed it against the back door of the nightclub. The fire consumed the door, traveled down the corridor, and burned above the heads of those on the dance floor. About 150 patrons fled the building, and no injuries were reported. (Below, photographer unknown, courtesy of the Monterey Fire Department.)

On March 18, 1971, the residence of 751 Dry Creek Road was completely involved in fire before the arrival of the fire department. According to the babysitter, she smelled smoke while doing dishes. The smoke was coming from the master bedroom; she called the fire department and fled the residence with the dog; the children were outside playing. Pictured below, Capt. James Kavanagh attacks the fire with a hose stream, and the flames begin to subside. The residents said the day was warm and they had opened the windows for ventilation. Since the house was mostly glass, it did not take long for the fire to run through the residence. (Both, photographs by James Carmichael, courtesy of the Monterey Fire Department.)

Fire emits thick, black, acrid smoke from Doc's Automotive Body Shop, located on Del Monte Avenue, on July 24, 1974. The smoke is from the flammable materials used in painting automobiles. Below, unidentified off-duty firefighters come to the aid of their brother firefighters helping to man fire hose lines and assist in extinguishing of the fire. The fire closed down traffic along Del Monte Avenue, a main road into the downtown area. (Both, photographer unknown, courtesy of the Monterey Fire Department.)

On June 27, 1976, Jolly Rogue Restaurant goes up in flames, forcing over 200 patrons to flee from the restaurant, located above offices and retail shops that were also still occupied when the fire started. The fire was reported at 7:40 p.m., and when engines arrived, smoke was pouring from the building. The restaurant was completely involved with fire. Capt. Michael Ventimiglia (left) backs up firefighter Bruce Henry on a 2.5-inch hose line from Wharf II. As reported by one of the employees, the fire started from the linen closet, and there was an estimated damage of $500,000. Pictured below on July 2, 1983, a $1-million fire occurred in a warehouse located at Franklin and Washington Streets. Warehouses belonging to Russo's Furniture, Brinton's Hardware, Basic Designs, and Dore's TV Mart were totally destroyed by the fire. (Both, photographs by staff, courtesy of the Monterey Fire Department.)

On July 2, 1983, windows give way due to the heat and gases from a fire. The fire explodes outward from the warehouse, located at Franklin and Washington Streets. Debris and glass can be seen flying across the street. A fire engine was pumping water to hose lines at the fire hydrant across the street when the windows gave way without warning, startling the civilians crossing the street. Shown below, a fire destroyed Russell's Camera store at 420 Alvarado Street, formally the home of Village Hardware, on May 29, 1990. The fire department was called at 2:30 a.m. The camera store was nestled between two historic buildings, and luckily, the fire was kept from spreading to the buildings. The building in the background is the Monterey Fire Station No. 1, built in 1911 and vacated in 1959. (Both, photographs by staff, courtesy of the Monterey Fire Department.)

On January 7, 2003, the fire department responded to a fire alarm at Community Hospital of the Monterey Peninsula, but no fire was located in the building. Upon leaving the scene, smoke was visibly coming from the roof that was unrelated to the initial call. Earlier, roofers had been doing repair work and ignited the underlayment of the hospital roof. Due to the roof construction, it took nearly four hours to extinguish the fire, and several fire units from different agencies aided in the effort. On February 7, 2007, Monterey was to suffer one of its worst fires, destroying 22 businesses in the downtown area on Alvarado Street. Pictured below are, from left to right, Capt. James Courtney, engineer Robert Wilkins, and firefighter Cosimo Tilly. (Both, courtesy of the author.)

Firefighters go on the defense, attacking from the rear of the building off Tyler Street during the February 7, 2007, Alvarado Street fire. Aerial ladder hose streams are used to penetrate the interior of the building and extinguish the flying embers. Pictured below is a view of the fire from Alvarado Street, with Rescue 6461 in front of Engine 6411 and crew applying water with the engine turret. The fire was determined to have started in the basement of Quizno's Sandwich Shop. The 100-year-old building, built in 1906, had few fire safety features, and the fire went between the walls of the adjacent building and came out on the second floor, destroying all of the businesses on that floor. (Both, courtesy of Andrew Kennedy.)

Firefighters manning aerial ladder pipes are silhouetted against the early morning sky as they continue to put water on the smoldering Alvarado Street fire. The loss was well into the millions of dollars and placed numerous people out of work. The site still remains vacant at the writing of this book, leaving a vacant lot in the middle of the downtown. Pictured below on July 10, 2009, fire once again strikes downtown Monterey. The fire ripped through the basement of Jugem Japanese Restaurant, destroying the restaurant and the offices located above on the second story. Pictured in the foreground is the department's new tiller aerial. (Above, courtesy of Andrew Kennedy; below, courtesy of the author.)

On July 10, 2009, fire personnel peer into the front windows of Jugem Japanese Restaurant as the restaurant's dining-room floor collapses into the basement. Unbeknownst to the firefighters, a concrete floor had been laid over the wooden floor and caused it to collapse. Earlier, firefighters were crawling though the restaurant looking for the fire, which began in the basement. Pictured below on November 12, 2010, fire runs through the second story of a three-unit apartment house at 699 Drake Street. The occupants smelled smoke and began looking for the source. One of the bedroom doors felt warm, and when they opened the door, the fire shot though the upstairs unit, destroying everything in its path. Fortunately, occupants were not injured. (Both, courtesy of the author.)

Five

FIRE APPARATUS AND FIREBOATS

Fire apparatus date back to the time of Benjamin Franklin and before. Benjamin Franklin, being one of the first volunteer firefighters in the nation, often spent time developing ideas of how water could be delivered to extinguish fires. After a huge fire in Philadelphia in 1736, Franklin created a fire brigade called Union Fire Company with 30 volunteers. Fire apparatus have gone through an evolutionary process from the first hand-pulled hose carts to horse-drawn hose wagons, hand pumpers, and steam engines. The Monterey Fire Department is no different than most cities when it comes to its fire apparatus; it takes pride in maintaining and caring for these apparatus. The Monterey Fire Department switched from hand-pulled hose carts, hook and ladder, and hose wagons to motorized apparatus in 1916. Monterey's first modern fire station was built in 1911 and was equipped with four stalls for horses, but horses were never brought into the station. On April 27, 1915, a bond issue was passed to purchase the city's first motorized fire apparatus, and on December 8, 1915, the city council voted to purchase the new fire engine, starting the transition to a mechanized fire department. The bid for the first fire engine was awarded to Seagrave Company, and in 1922, a second Seagrave fire engine was purchased. Just as fire engines progressed over the years, aerial fire apparatus became an important firefighting tool. As buildings became taller, firefighters could no longer use ground ladders carried on the fire engines to get to the windows of the upper stories in buildings. The aerial ladder company would become an essential for any modern fire department. Costal communities like the city of Monterey had still another problem that needed to be addressed—fighting fires from the seaward side. Fireboats were essential in firefighting as the seaward side of canneries and wharfs and boat fires could only be extinguished with the aid of a fireboat.

Shown on March 22, 1884, this was the first hose cart used to protect the citizens of Monterey. The hose cart is on display at fire station No. 2. With a worn body and sagging wheels, if this hose cart could talk, it would tell amazing stories of fires and the men who pulled it along the roads in Monterey. Pictured below on June 15, 1908, the fire department purchased this American LaFrance bicycle-racing cart from Elmira, New York, for $300. The description reads, "Racing Hose Cart with Rope Reel and Six-Foot Wheels." The six-foot wheels were made of steel, as were the spokes. The hose cart was to be used for competition and was considered state of the art for racing carts. (Both, photographer unknown, courtesy of the Monterey Fire Department.)

The Sanborn map of 1905 lists a hose wagon on the Monterey Fire Department inventory. A brass plate on the side of the hose wagon listed R.S. Chapman as sales agent; the office was located in San Francisco on North Fremont Street. On December 8, 1915, the city council authorized the purchase of the first mechanized fire engine for the fire department. Below, volunteer firefighters test the new 1916 Seagrave fire engine to see what it can do. The fire engine came with hard rubber tires, which made the ride quite bumpy, but one did not have to worry about changing flat tires. (Both, photographer unknown, courtesy of the Monterey Fire Department.)

Restoration of the 1916 Seagrave occurred 70 years after it was purchased, on October 1, 1986. Over the years, the 1916 Seagrave fire engine was modified, and so the fire department embarked on trying to restore it to its original grandeur. The fire engine was retired from active service on July 11, 1956; its first fire was June 27, 1919, when the T.A. Work lumber mill, located at David Street and Lighthouse Avenue in New Monterey, burned. Pictured below in 1933, the department's 1922 Seagrave fire engine receives pneumatic tires to replace the hard rubber tires it came with. Pictured are, from left to right, Roland Ingles, a mechanic at the tire shop; engineer Harry Shaw in the driver's seat; and fire chief William E. Parker. (Above, courtesy of the author.)

Pictured on November 9, 1947, are fire station No. 1, located on Calle Principal Street, and the fire apparatus station. Apparatus include, from left to right, the fire chief's sedan, a service unit for lighting, the 1946 Mack fire engine, the 1922 Seagrave fire engine, and the 1916 Seagrave fire engine. Pictured below on May 5, 1951, twin Mack fire apparatus sit on the ramp at fire station No. 3. The Mack fire engines were purchased for the opening of the new fire stations, one for Del Monte Grove and the other for New Monterey. Both engines were rated at 1,250 gallons per minute and equipped with a 300-gallon water tank, a high-pressure booster pump, and open cabs for visibility.

Fire apparatus is seen on the apron of fire station No. 3 on August 20, 1956. Visible are, from left to right, a GMC utility pickup, which was used for carrying equipment and fire hose to and from fires; the 1916 Seagrave fire engine; a service engine, which was modified for a fire pump installed in front of the unit; and one of the 1951 Mack fire engines. Pictured below is the vintage 1950s Rio Civil Defense unit, which was on loan to the fire department from the State of California Office of Civil Defense to respond to nuclear attacks. The 1950s and 1960s were a time when the United States focused on the possibility of nuclear attacks by foreign countries. Firefighter William Ives displays the unit to the public. In case of nuclear attack, the unit was equipped with heavy-duty rescue equipment and radiological monitoring equipment.

Beginning on May 18, 1966, the fire department started having more grass and brush fires. The fire department modified an Army 2.5-ton truck into a water tanker. Capt. Joseph Cerchi, who was a welder, headed up the project, and upon its completion, the tanker was given the nickname "Honey Bucket" due to it being painted safety yellow. Pictured below on September 22, 1952, the fire department received its first aerial ladder truck. The 65-foot Seagrave aerial ladder owned by the Naval Postgraduate School was given to the city for providing fire protection to the Naval Postgraduate School. A bond issue was passed in 1920 for an aerial ladder truck, but the city could not decide on the type, and the bonds were burned. (Both, photographer unknown, courtesy of the Monterey Fire Department.)

In 1959, the department replaced the aging Seagrave aerial ladder with a new 85-foot American LaFrance aerial ladder truck. The aerial ladder truck was equipped with a high-pressure booster pump, a 200-gallon water tank, life nets, and ground ladders. Pictured below in 1989, a 105-foot aerial platform was purchased for $430,000 and weighed 74,000 pounds. It was built by the Canadian Thibault Company and replaced the 1959 American LaFrance aerial ladder truck. The aerial platform would allow firefighters to apply water to a fire with an automatic nozzle and could be operated from the ground. Once secured in the platform basket, citizens could be lowered onto the street after being safely rescued from buildings. (Both, photographer unknown, courtesy of the Monterey Fire Department.)

Pictured on October 1, 2010, is the department's new 2008 KME tiller truck with a 100-foot aerial ladder. The KME tiller truck replaced the Thibault platform tuck. The KME tiller was purchased for its ability to navigate the narrow streets in the city and carry rescue equipment for traffic accidents when automobile extrication was needed. Pictured below on October 20, 2010, is the department's newest state-of-the-art Pierce fire engine. (Both, courtesy of the author.)

Here is an interior view of the new Pierce fire engine. Incredibly more advanced than the department's first fire apparatus over 94 years ago, this fire engine is equipped with mobile data computers, hearing protection for firefighters, and communication systems. Safety features for the firefighters are essential when responding in the fire apparatus. On May 17, 1949, the Monterey Fire Department took possession of its first fireboat, a retired tugboat, shown below. The tugboat engine was rebuilt, and fire pumps were installed at Monterey Boat Works. Fire chief Gregory Teaby is on deck in uniform, standing next to the wheelhouse. The fireboat was purchased to provide fire protection to the fishing fleet, canneries, and wharfs. (Above, courtesy of the author.)

On July 3, 1953, unidentified firefighters respond to a boat fire in the harbor with the fireboat *William E. Parker*. Pictured below on December 29, 1962, the city purchased the 1962 Valco Jet boat to replace the retired *William E. Parker*. Over the years, *William E. Parker* had several mishaps and was dubbed by the press the "Little Squirt." The fireboat often ran into problems when dispatched to an emergency, causing it to fail in its mission. Those pictured are, from left to right, assistant chief Robert Wigham, an unidentified firefighter at the nozzle, and Capt. William Henley in the black and white helmet. They are putting the new fire lightweight fireboat through its paces in testing its maneuverability. (Below, photographer unknown, courtesy of the Monterey Fire Department.)

The Valco fireboat would be retired in the late 1970s. Seawater would take its toll on both the aluminum hull and engine. Fire crews would often be towed back to port, which was embarrassing to say the least. The fireboat program was revived in 1998, when an experimental fireboat built on a Zodiac hull was purchased; it served the department until 2005. Those pictured are, from left to right, an unidentified diver, Capt. Barry Perkins, firefighter James Courtney (behind wheel), and firefighter Ewell "Buzz" Cole. Pictured below on March 2, 2011, is the department's latest fireboat, named *Pearl*. The department purchased it with a grant from Homeland Security based on regional needs. (Above, courtesy of Capt. Barry Perkins; below, courtesy of the author.)

Six
Fire Department Personnel

A fire department in name is just an empty shell. The personnel within a department make it come to life, coming together to form a firefighting force to provide emergency services to the community. Over the last 129 years, Monterey Fire Department has been fortunate to have within its ranks firefighters who have shaped and molded the department by giving of themselves for the greater good of the community. All firefighters share a common bond, much like the bond between brothers and sisters, which most of the general public does not understand. It is an occupation that relies on the support of every team member coming together in times of emergency to overcome obstacles, whether fires or catastrophic events. Like with most things in life, a good foundation is necessary. This department has been fortunate to have had strong leaders, beginning with fire chief William E. Parker, who set the pace of the department by serving in that role for 52 years. Uniforms that the firefighters wear or the patch on their sleeve may change over the years, but what remains constant is the pride and heart of the individual firefighters who wear the uniform. A fire department can be a great one or just average; it is the attitude of the firefighters that decides the type of department it will become. The following chapter will take a look, from the very beginning in the late 1800s to today, at the firefighters who gave of themselves. There is a common bond with these men and women, which is the need to serve their community.

In 1890 in San Francisco, William E. Parker poses after being named fire chief by the city fathers. The lapel buttons are five crossed trumpets, the insignia of the fire chief. Pictured below on March 4, 1890, fire chief W.E. Parker is in center of the first row with a beard. He is pictured with unidentified officers and members of the Monterey Fire Department. The individuals in the front row holding the speaking trumpets are company officers. The department flag is to the left with the date March 4, 1890, which is when the fire department was chartered by the city. (Left, photograph by Abell and Priest; below, photographer unknown; both, courtesy of the Monterey Fire Department.)

Men of hook and ladder company No. 1 stand in front of the Cooper Molera historical adobe at the intersection of Pearl and Alvarado Streets in 1897. Those pictured are, from left to right, (standing) firefighters Manuel Perry, Willie Bergshicker, Eleazer Whitcomb, Manuel Silva, Joseph King, Albert Chaine, and Joseph Schulte with trumpet; (sitting) Joseph Feliciano, Elemelie Feliciano, and Tony Vidal. Pictured below on September 9, 1909, are members of the Monterey Fire Department racing team. They set a record at San Jose, California, running 200 yards in 23.5 seconds. Firefighters have always had competitive sprints. For example, in the early days, it was a triumph to draw first water on a fire, beating out the other fire companies. (Both, photographer unknown, courtesy of the Monterey Fire Department.)

Here is hose cart station No. 2, located in New Monterey around 1912. The new hose cart company was formed on March 8, 1905. The 1912 Sanborn map established a hose cart company at 518 Hawthorne Street, the approximate location where fire station No. 2 is today. The firefighters are unidentified. They are wearing belts with metal buckles inscribed with "Monterey Hose Co." The firefighter in the center is holding one of the early nozzles. The third firefighter from the left holds a speaking trumpet, which was used to give commands at the fire. Young children of the firefighters hold rope that was used in various tasks, like rescuing individuals. Pictured below, unidentified volunteer firefighters and the general public observe the trial test of the new 1916 Seagrave at Wharf II. (Both, photographer unknown, courtesy of the Monterey Fire Department.)

Pictured in 1920, Manuel S. Perry, one of the first paid firefighters in the department, was presented a gold badge in 1909 for most faithful service during the year of 1908 by Charles R. Few, the fire department secretary. The remainder of the department was comprised of 105 volunteer firefighters. The gold badge that was presented to Manuel S. Perry was purchased in 2010 by a private collector from Sacramento at a fire department paraphernalia sale. Pictured below on September 3, 1922, is a water fight between members of the Monterey and Pacific Grove Fire Departments. Unidentified firefighters participate while civilians watch the event. The two departments would come together as one fire department in 2008. (Both, photographer unknown, courtesy of the Monterey Fire Department.)

Shown at the July 4, 1924, parade, engineer Harry Shaw is wearing a white tie and suspenders. The next three people to the right of him are, from left to right, an unidentified firefighter, Monty Hellam, and fire chief W.E. Parker, leaving the rest of the volunteers and paid firefighters in the photograph unidentified. Pictured below on September 24, 1924, fire chief William E. Parker stands in front of the main building of the Hotel Del Monte. His firefighters were able to save the two wings housing guests. The fire was said to have started with embers from one of the chimneys in the main building. This was the second fire for the Hotel Del Monte, with the first fire occurring on April 1, 1887. The first fire was believed to be arson, and a suspect was held over for trial. (Both, photographer unknown, courtesy of the Monterey Fire Department.)

Here on February 26, 1926, are Monterey Fire Department personnel at fire station No. 1 on Calle Principal Street. In the center of picture are, from left to right, Monty Hellam and fire chief William E. Parker (with the white hat). The other firefighters are unidentified. Monty Hellam's tobacco store is to the left of the fire station. The roadster at center was purchased through personal funds and donations for the fire chief's 36 years of continued service. The doors of the vehicle were inscribed with his initials. Pictured below on May 21, 1946, Monterey Fire Department firefighters stand by at Carmel by the Sea Fire Station. They are, from left to right, John Leppert, Chas Scudero, Tom Gormely, Frank Enes, Harry Shaw, Chester Williams, and Joe Myers. (Above, photographer unknown, courtesy of the Monterey Fire Department.)

Firefighters at fire station No. 1 on Calle Principal Street are seen with pulling harnesses and a hose cart on April 22, 1948. Those pictured are, from left to right, Elmer Paulsen, Manuel Solis, Cliff Messer, Leonard Said, Herb Bispo, Cliff Hebrard, Fred O'Donovan, Malcolm Colvin, Al Stal, and Douglas Grounds. Pictured below on February 17, 1949, members meet at fire station No. 1. In the back are Gregory Teaby, wearing a gray suit and tie on the left side; Harry Shaw, sitting on a table and wearing his uniform; William Stone, donning a stripped suit with glasses; Clifford Hebrard, standing to the immediate right of William; and Malcolm Colvin, sporting the leather jacket. William Ives is sitting behind sofa in his uniform, and sitting in chair with a hat on is John Leppert. Those on the sofa are, from left to right, Manuel Solis, fire chief Harvey T. Morgan, and Jean Carrere. All others are unidentified.

Those pictured on July 29, 1949, are, from left to right, an unidentified woman and firefighters Manuel Solis and Danny Martinez, the master of ceremonies for a fire department benefit dance. Benefit dances and fireman's balls were held to generate money for equipment and to provide aid to the families of injured firefighters. Pictured below in 1949 are, from left to right, firefighters William Henley, William Stone, and Donald Cavin. They are seen in the fire alarm room of fire station No. 1; the fire alarm boxboard is seen in the background. The fire alarm room is where signals from fire alarm boxes were received, and prior to central dispatch, the duty watch would receive telephone calls to report incidents. It was literally the nerve center through which all communications flowed.

Fire department personnel are seen in front of a Christmas display at fire station No. 1 on December 24, 1949. Those pictured are, from left to right, (first row) William Henley, Frank Enes, Ward Chant, Manuel Solis, and Clifford Hebrard; (second row) Lester Waddel, two unidentified, William Pacchetti, Lee Seigal, William Stone, Harry Shaw, Chester Williams, Gerald Gash, Harland Jones, Gordon Lewis, Claude Costa, William Ives, and unidentified. Pictured at left on May 14, 1950, firefighter Charles Della Sala is sliding down the fire pole upside down at fire station No. 1; firefighters love humor, as it often breaks up the seriousness of the job. Fellow firefighters look on from the fire engine and have a chuckle. Behind the steering wheel is firefighter Edward Bispo, and to his right is Capt. Clifford Hebrard.

Pictured above on March 27, 1953, are firefighters Robert Wigham (left) and Herbert O. Scales. They are pulling a double hose lay at the Ramsey Motors fire. Ramsey Motors was located on Tyler Street behind the State Theater. Robert Wigham went on to become the assistant chief for fire prevention, and Herbert O. Scales eventually became fire chief. Pictured at right on May 18, 1953, firefighter Malcolm Colvin is at the wheel of the fireboat, and firefighter Gordon Lewis enters the wheelhouse. They are performing a weekly fireboat drill. Fireboat *William E. Parker* was christened on May 30, 1951, by Clara S. Parker, the wife of fire chief William E. Parker.

From left to right, firefighters William Stone, Jack Reynolds, and Francis "Buzz" Winn are seen cleaning the hose cart and painting the antique fire apparatus on August 15, 1954. Their goal was to help preserve the department's historical equipment and the department's heritage. Pictured below on August 14, 1954, are, from left to right, firefighters Donald Cavin, Eugene Sanderson, and Harvey Hillbun. They are cleaning and conducting maintenance on the department's vintage hose wagon, which dates back to the early 1900s and is still in good condition today.

Shown on January 2, 1955, are crewmembers from fire station No. 1. They are, from left to right, Eugene Sanderson, William Ives, Capt. Harry Shaw, Francis "Buzz" Winn, and Harvey Hillbun. Pictured at right on October 9, 1955, service testing the fire apparatus at Lake El Estero are, from left to right, firefighters William Henley, Robert Wigham, Brooks Bowhay, and unidentified. The buildings in the background along Del Monte Avenue were a moving company's transfer and storage warehouses; they were razed by the city to make way for the Window by the Bay Park.

The firefighters service testing the 1951 Mack fire engine at Lake El Estero are, from left to right, unidentified, Herbert O. Scales, unidentified, Donald Cavin, and an unidentified little boy on October 19, 1955. Pictured below on March 3, 1956, firefighters are performing fireboat maintenance on *William E. Parker*. They are, from left to right, Jack Reynolds, Donald Cavin, Herbert O. Scales, and Francis "Buzz" Winn on top of wheelhouse. An additional three firefighters were hired in 1951 to man the fireboat. They were assigned to fire station No. 1. They worked at the breakwater, which was where the fireboat was located during the day, and had to return to the fire station at night.

On July 21, 1956, engineer mechanic Alvin Ernst (in white coveralls) is seen with unidentified personnel. Alvin Ernst was the fire department mechanic; he maintained and serviced all the department's apparatus, including the fireboat. The fishing boats in background are purse seiners and were used in the catching of sardines. They were expensive to build and were essential to the economy of Monterey; fire protection for the fishing boats came from the fireboat. Pictured below on January 1, 1957, are firefighters Charles Della Sala (left) and Donald Cavin in front of fire station No. 1.

On April 3, 1958, Lake El Estero floods Del Monte Avenue at Camino El Estero due to heavy rains. Unidentified firefighters are given the task of trying to lower the water level to keep the water from entering a moving company's transfer and storage warehouses along Del Monte Avenue. The site is now the Window to the Bay Park, and flood control pumps have been installed. Pictured below on May 4, 1958, firefighters meet for a meal at Hermann's Restaurant on lower Alvarado Street. The restaurant, along with the Assembly Cigar Store, was razed to make way for the Osio Plaza. Those pictured are, from left to right, (first row) Eugene Roncarati, Herbert O. Scales, Manuel Solis, Charles Della Sala, and Francis "Buzz" Winn; (second row) Ward Chant, Raymond Crivello, Joseph Cerchi, James Kavanagh, and Danny Martinez.

In front of fire station No. 1 on Pacific Street in 1959 are, from left to right, (first row) firefighters Jack Barlich, Alfred Long, and David Van Woerkom; (second row) Capt. Jack Reynolds and firefighters Charles "Ted" Bell and Francis Forbes. Pictured below on April 26, 1959, in front of fire station No. 1 on Pacific Street are, from left to right, Capt. Charles Della Sala; engineer Eugene Roncarati; firefighters Ward Chant, Donald Cavin, and Frank DiMaggio; engineer Alfred Long; and Capt. Manuel Solis.

On April 26, 1959, firefighters pose for a picture in front of fire station No. 1 on Calle Principal Street. They are, from left to right, (first row) Clifford Hebrard, Jack Reynolds, Jim Lesch, Alfred Long, Frank DiMaggio, Charles Della Sala, and William Stone; (second row) Charles Maxwell Kelly, Richard DeLorimier, Donald Cavin, Charles "Ted" Bell, Brooks Bowhay, John Polesko, Ward Chant, and Joseph Cerchi. Pictured below displaying the trout they caught on their annual fishing trip to Lake Almanor in the Sierra Nevada in Northern California are Robert Wigham (left) and Claude Costa at fire station No. 2 on May 30, 1959.

Pictured in June 1960 are, from left to right, firefighters William Lane, Lester Waddel, James Kavanagh, and Eugene Roncarati. They are dressed up as a female chorus line to entertain brother firefighters at a benefit function for the fire department. Pictured below in 1961 are, from left to right, Alfred Long, Charles "Ted" Bell, Francis Forbes, Donald Castillo Jack Barlich, and David Van Woerkom in front of fire station No. 1 on Pacific Street.

In May 1961, members of fire station No. 2, located on Hawthorne Street in New Monterey, are standing in front of the 1951 Mack fire engine. They are, from left to right, firefighter Francis "Buzz" Winn, Capt. William Ives, firefighter Larry Amador, and college student William Campbell. In the 1960s, the fire chief embarked on a program that would allow college students to live in the fire station; the only stipulation was that they had to respond to calls. Pictured at left on July 3, 1965, firefighter John Polesko cleans the department's pride and joy, the 1916 Seagrave fire engine.

Firefighter Richard Campbell polishes and cleans the antique hose wagon, which has a historic service record within the fire department, on July 30, 1965. Pictured below on July 16, 1965, a fire muster is held in the city of Carmel by the Sea. Pulling the Monterey Fire Department's 1906 bicycle racing cart are, from left to right, (first row) Capt. Charles "Ted" Bell and firefighter Edward Brown; (second row) firefighters Brian Leidig and Edward Stevens. Standing behind the hose cart, assistant chief Frances Forbes prepares for the race. (Both, photographer unknown, courtesy of the Monterey Fire Department.)

Those pictured on January 6, 1966, are, from left to right, firefighters Richard Campbell and Raymond Crivello They are cleaning up after a fire in a residence. Pictured below is the 1967 Oil Fire School, located at the Monterey Airport Naval Air Station training ground. Local fire departments would attend this three-day training school to get first-hand instruction on how to handle liquid petroleum fires. The school would not be allowed under today's environmental safety standards. (Both, photographer unknown, courtesy of the Monterey Fire Department.)

Firefighter Richard DeLorimier is exhausted after working a residential fire on October 13, 1967. Self-contained breathing apparatus were not always available, and carbon monoxide in the air from the smoke produce fatigue in the firefighters. Pictured below, probationary firefighter Michael Ventimiglia receives training on how to use a canister mask since self-contained breathing apparatus, like the one the officer is wearing, were too expensive to provide to all firefighters. Federal and state laws would later require fire departments to provide self-contained breathing apparatus and other safety equipment to firefighters. (Both, photographer unknown, courtesy of the Monterey Fire Department.)

Pictured cleaning up after a residential fire on January 30, 1969, are, from left to right, engineer Malcolm Colvin with hose and firefighters Frank Mulchaey, unidentified, and L.D. Higgins. Working a residential fire below on January 3, 1969, are, from left to right, senior captain Stanley Lewis, fire chief Herbert O. Scales, and Capt. James Kavanagh. Firefighters would often respond to fires from home without safety equipment or self-contained breathing apparatus and work the fire. Occupational health and safety laws would bring an end to this practice. (Both, photographer unknown, courtesy of the Monterey Fire Department.)

Shown in 1976 are, from left to right, (first row) firefighters Demetrius Kastros, William Harrigan, and Robert McCay; (second row) firefighters Michael Downing, Michael Cooley, and Raymond LaFontaine; engineer Robert Greathouse; and Capt. Michael Ventimiglia. Pictured below on August 1, 1978, members of A-Platoon are, from left to right, (kneeling) Kenneth Blankenship, Felix Colello, Pete Solt, Robert Lowery, Benjamin Obligacion, and Garland Blanton; (standing) Michael Cooley, Robert McCay, Richard Lewis, Battalion Chief James Kavanagh, Paul Goodwin, Christopher Miller, Daniel Shirey, Christopher Smith, and George De Leon. (Both, photographer unknown, courtesy of the Monterey Fire Department.)

Before entering a building to check if a fire has been extinguished in 1982, firefighter Michael Cooley puts on a self-contained breathing apparatus under the watchful eye of Capt. Raymond Savage. Pictured below while attending wildland firefighting school in 1984, men find time to pose for this picture. They are, from left to right, Capt. Michael Cooley, John Caniglia, Guy Pruitt, Arthur Webb, Felix Colello, unidentified, and Marcial "Marsh" Del Rosario. (Both, photographer unknown, courtesy of the Monterey Fire Department.)

At the 1991 appreciation breakfast hosted by the City of Monterey for its employees, Capt. Raymond LaFontaine, firefighter Daniel Barker, engineer Robert McCay, an unidentified lady, and Capt. Garland Blanton are shown from left to right. Pictured below at the appreciation breakfast are, from left to right, Capt. David Goodwin, firefighter Ewell "Buzz" Cole, firefighter John Caniglia, engineer Hal McKay, engineer Kevin Murdock, and Capt. Raymond LaFontaine. (Both, photographer unknown, courtesy of the Monterey Fire Department.)

In 1991, fire station No. 1 firefighters come together in the kitchen for a photograph opportunity prior to sitting down for dinner. Those shown are, from left to right, Capt. Thomas Welle; firefighter Christopher Back; engineer David Reade; and firefighters Roger Reed, Mike Nuno, Felix Colello, and Brian Pratt. Pictured below in 1992, Capt. Larry Goodson is working the fire command room at a Monterey Plaza Hotel joint agency drill. Large-scale multiagency drills are often conducted, as there are not enough resources in one city when large fires occur, and fire departments depend on mutual aid. (Above, courtesy of the author; below, photographer unknown, courtesy of the Monterey Fire Department.)

Firefighters graduate from the fire department academy on November 29, 1993. Those pictured are, from left to right, firefighters Lucero "Lou" Valdez, Robert Wilkins, and Kelly Moore Davidian. Firefighter Kelly Davidian would go on to be promoted to the rank of captain. So far in the department's 129 years of history, she is the only female firefighter to be promoted to captain. Pictured below in 1996 are, from left to right, training officer William Vandevort, Capt. Stewart Roth, firefighter Christopher Back, and an unidentified firefighter at the foot of the extension ladder. It looks as though Vandevort is explaining the essentials of knot tying to the others. (Above, photographer unknown, courtesy of the Monterey Fire Department; below, courtesy of the author.)

In 1996, Monterey fire personnel were dispatched to a wildland fire on state mutual aid. They are, from left to right, firefighter Lucero "Lou" Valdes, engineer Felix Colello, Capt. Christopher Miller, and unidentified. Pictured below in 1998, fire station No. 1 crewmembers are, from left to right, (seated) engineers David Reade and Felix Colello and Capt. Stewart Roth; (standing) division chief Michael Ventimiglia and firefighters Larry Sands, Christopher Smith, and Jon Abers. (Both, photographer unknown, courtesy of the Monterey Fire Department.)

On March 5, 1999, the fire department practices drills on Alvarado Street in the downtown area. Those pictured are, from left to right, Richard Johnson, putting on a breathing apparatus; Matthew "Jib" Bowe; and fire engineer Robert Lowery. Pictured below, division chief Michael Ventimiglia receives his 30-year service award; he started service with the department in 1969. Those shown are, from left to right, (first row) secretary Moniel Feuerman, engineer Hal McKay, division chief Michael Ventimiglia, fire chief John Montenero, firefighter Daniel Barker, division chief Stewart Roth, and office assistant Rhoda Lefkof; (second row) firefighter Marcial "Marsh" Del Rosario, Capt. Barry Perkins, Capt. David Potter, Capt. Mike Downing, engineer Robert Wilkins, firefighter John Caniglia, and engineer Kelly Moore Davidian. (Both, photographer unknown, courtesy of the Monterey Fire Department.)

On October 20, 2001, firefighters celebrate the marriage of engineer Kelly Moore Davidian, one of their sister firefighters. From left to right are firefighters Dan Barker and Cosimo Tilly; division chief Stewart Roth; Capt. Barry Perkins; division chief Michael Ventimiglia; engineer Hal McKay; firefighter Christopher Smith; Capt. Raymond LaFontaine; firefighter James "J.D." Sheldon; engineers Timothy Sloan, Kenneth Zimmerman, and Ewell "Buzz" Cole; and firefighters James Brown, John Caniglia, and Rose Sloan. Pictured below on July 17, 2002, Capt. Raymond LaFontaine receives the Medal of Valor from fire chief Gregory Glass for retrieving a seriously injured child being attacked by two rottweiler dogs. In attendance are, from left to right, police chief Carlo Cudio, deputy chief Timothy Shelby, and personnel director Ralph Bailey; others are unidentified. (Above, courtesy of the author; below, photographer unknown, courtesy of the Monterey Fire Department.)

November 25, 2003

Division chief Michael Ventimiglia, pictured on Octover 25, 2003, next to his incident command vehicle, was hired by the City of Monterey in 1969 and served as a division chief for 27 years. Pictured below on December 15, 2003, members of C-Platoon taking a lunch break at Bi-Rite Market between company performance drills at fire station No. 3 are, from left to right, Mark Thomas, Kelly Moore Davidian, Michael Ventimiglia, John Caniglia, Stewart Roth, Cosimo Tilly, Ewell "Buzz" Cole, and Raymond LaFontaine. (Both, courtesy of the author.)

Pictured on December 7, 2004, fire department members are, from left to right, (first row) Michael Cooley, Eric Rodewald, Gregory Glass, Kathleen Battaglia, Roberta Greathouse, Gemma Dailey, Stewart Roth, Michael Ventimiglia, and David Potter; (second row) Kenneth Zimmerman, Daniel Barker, Steve Steinbach, John Caniglia, James Courtney, and Cosimo Tilly; (third row) Russell Stopper, Roger Reed, Matthew "Jib" Bowe, Ewell "Buzz" Cole, and Robert Wilkins; (fourth row) Kevin Murdock, Raymond LaFontaine, Kelly Davidian, Marcial "Marsh" Del Rosario, Brendon Hamilton, and Samuel Prada; (fifth row) Graham Fenwick, Felix Colello, Arthur Webb, Paul Goodwin, and Jason Boyer; (sixth row) James Brown, Barry Perkins, Mark Thomas, James Pagnella, Christopher Smith, Bob Flood, and Patrick Moore. (Courtesy of the author.)

Several weeks after the February 7, 2007, Alvarado Street fire, deputy fire marshal David Reade is allowed into the basement area to investigate the cause and origin of the fire that destroyed 22 businesses. Pictured below on December 16, 2008, Pacific Grove fire personnel become employees of the City of Monterey and are sworn in. Those pictured standing in line are, from left (the rear wall) to right, David Potter and Felix Colello, division chiefs for Monterey; Pacific Grove employees Jim Gunter, Jon Selbicky, Joe Silva, Frank Consiglio Jr., Jeff Field, Fred McAlister, Jeff Heyn, Mike Wallace, John Crocker, Andrew Miller, Anthony Silva, Danny Givven, Elliot Rubin, Brian Wilkins, Justin Cooper, Gregory Greenlee, and David Brown; and fire chief Sam Mazza. They are reciting the oath of office. (Both, courtesy of the author.)

On October 24, 2009, from left to right, engineer Robert Wilkins, Capt. James Brown, and Capt. Roger Reed are seen in front of aerial tiller truck during Fire Prevention Week's open house. Pictured below, division chief David Brown (left) talks with his brother Capt. James Brown (right); the brothers were united when Pacific Grove Fire Department merged with Monterey Fire Department. The Browns come from a local family of firefighters. (Both, courtesy of the author.)

On October 29, 2009, office administrative staff members included Gundy Rettke (left) and Kathleen Battaglia (right). They were responsible for organizing the fire department's open house during Fire Prevention Week, which was no easy task. Fire, police, American Red Cross, ambulance, CERT teams, and private companies come together for the general public to review the emergency services that are available. Pictured below on January 16, 2011, are, from left to right, firefighter Brian Wilkins, Capt. Raymond LaFontaine, and firefighter Christopher Back. They are crewmembers of fire station No. 3, A-Platoon. (Both, courtesy of the author.)

On March 1, 2011, engineers Ewell "Buzz" Cole (left) and Patrick Moore (center) and firefighter Gregory Greenlee from fire station No. 3, C-Platoon, gather for a picture. Those pictured below are, from left to right, (first row) police officer Phil Penko; (second row) city manager Fred Meurer, firefighter Danny Givven, and division chief Stuart Roth; (third row) Chief Andrew Miller and assistant city manager Fred Cohn; (fourth row) unidentified. The City of Monterey activated the Emergency Operation Center when the March 2011 tsunami hit Japan, and the fire department assisted in notifications along the waterfront areas of the cities. (Both, courtesy of the author.)

Pictured on March 12, 2011, are, from left to right, Capt. Graham Fenwick and firefighters Jarred Neal and Christopher Williams at fire station No. 3, A-Platoon. Pictured at right attending a ceremony for two firefighters being promoted to the rank of engineer on March 22, 2011, are Capt. Robert Flood (left) and Capt. Jeffery Heyn. (Both, courtesy of the author.)

Attending a department promotional ceremony on March 22, 2011, are, from left to right, engineer Ewell "Buzz" Cole in civilian clothing, engineer Patrick Moore, two unidentified children, and Capt. Luis Valdez. Pictured below on March 22, 2011, from left to right, fire chief Andrew Miller administers the oath of responsibility to firefighters Jarred Neal and Brendon Hamilton, who are being promoted to the rank of engineer. (Both, courtesy of the author.)

Pictured on March 22, 2011, are, from left to right, engineer Joe Silva, firefighter Vincent Lombardi, firefighter Brian Holm, and Capt. Roger Reed of fire station No. 1, A-Platoon. Pictured below on March 22, 2011, are, from left to right, firefighters Brian Wilkins, Marcial "Marsh" Del Rosario, and John Caniglia and Capt. John Crocker of fire station No. 1, A-Platoon. (Both, courtesy of the author.)

119

Pictured on March 22, 2011, are, from left to right, engineers Jon Selbicky and Joe Silva; firefighter Brian Wilkins; engineer Jeffery Fields; firefighter Vincent Lombardi; Capt. Roger Reed; firefighters Brian Holm and Marcial "Marsh" Del Rosario; Capt. Barry Perkins; firefighter John Caniglia; and Capt. John Crocker of stations Nos. 1 and 2, A-Platoon. Pictured below on March 31, 2011, are, from left to right, Capt. Arthur Webb, engineer Ewell "Buzz" Cole, and firefighter Gregory Greenlee of fire station No. 3, C-Platoon. (Both, courtesy of the author.)

Seven
ONCE UPON A TIME

Fire service has evolved over time, improving fire apparatus and equipment and providing modern-day firefighters with the specialized equipment needed to do their job. Early fire alarm systems, like the Gamewell Fire Alarm System installed in Monterey in 1905, no longer exist, and the street alarm boxes have been removed. Some cities like San Francisco still use fire alarm street boxes, one of the reasons being that it is a means of communication. San Francisco, being a multi-cultural city, has a population that speaks many languages. The citizens, however, are all taught to pull a fire alarm if in trouble or in need of help. The fire alarm street box system still has value but is often used not for its intended purpose. Fire alarm street boxes were removed from the streets in Monterey as new technology found its way into the fire department. Improvements in equipment, fire stations, and fire apparatus affect the outcome of a department and the level of service it is able to provide to its citizens. This last chapter showcases some of the early equipment, Sanborn maps, original locations of fire stations, population, and hydrants, and the size of the department at given points in time. The Sanborn map was a principal tool used in the early fire insurance industry to assess liability in urbanized areas in the United States. Sanborn maps consisted of individual pages constructed in a book format similar to an assessor parcel map book. The Sanborn map book gave the following information: address, street location, building construction type, water main, hydrants, and other information pertaining to the services located in the city. Approximately 12,000 US towns and cities from 1867 to 1970 used Sanborn maps.

The Sanborn map of 1892 showed the population at 1,700 citizens. The fire department consisted of one independent hose cart. The city received its water from the Carmel River through cast iron water mains 12 inches and 18 inches in diameter. The average water pressure throughout the city was 80 pounds per square inch, and there were 12 fire hydrants in various locations around the city. The 1912 Sanborn map below estimated the population of the city at 5,000 citizens. The fire department had four hose carts, one vintage hook and ladder wagon, 100 volunteers, and a fire alarm system with 13 street boxes. There were now 47 fire hydrants in various locations throughout the city. (Both, courtesy of the Los Angles Library.)

The Sanborn map of 1905 locates the fire department at 410 Main Street, which will later be renamed Calle Principal Street. The firehouse was described as a wood-frame, barn-style building with wood stud walls and a dirt floor. Fire apparatus consisted of one combination hose wagon carrying four 3-gallon containers of chemicals, one vintage hook and ladder wagon, and one hose cart. The fire department had 61 volunteers who responded to fires. An electric fire alarm system with 12 street boxes was being installed in the city at various locations. Pictured below, the Sanborn map of 1912 places hose cart 3 at station No. 2, located at 518 Hawthorne Street in New Monterey. An empty lot was at that address in 1905. (Both, courtesy of the Los Angles Library.)

123

Hose cart company No. 4 in the Oak Grove area of Monterey was added to the fire department. The Sanborn map of 1912 locates the hose cart company at 1108 Fifth Street. On February 4, 1914, Oak Grove Hose Cart Company No. 4 hosted an initiation and dinner at the house, according to the local newspaper. Pictured below, fire chief William E. Parker's original Cairn's and Brothers leather fire helmet, with his name and department initials hand carved into the helmet shield, has the patent date of September 11, 1877. Members of the fire department presented the fire helmet to the fire chief on July 4, 1892. (Left, courtesy of the Los Angles Library; below, courtesy of the author.)

This early 1884 fire helmet worn by the firefighters in hose cart company No. 1, which was organized on March 22, 1884, is made of leather with a hand-carved helmet shield. Hose cart company No. 1 was located in downtown Monterey. Pictured below is an early face mask that was connected to a filter canister, which was often used in the mining industry but was adapted to firefighting. (Both, courtesy of the author.)

On March 22, 1905, the city purchased of a fire alarm and police patrol signal system; it had 12 fire alarm boxes covering Monterey, Oak Grove, and New Monterey. The fire alarm system made by Gamewell was the city's first system. The system was removed on March 31, 1981, and 77 street boxes in the city became silent. Pictured below is a fire alarm signal device that was used by fire officers in their homes; the signaling device would ring out the numbers of the street box location. The fire officer would use the telegraph key to signal the receipt of the alarm. Each fire alarm street box was given a number and the intersection where it was located. (Both, courtesy of the author.)

A voting box was used to accept new members into the fire department. A member of the department would be given a white ball and a black ball. The drawer was opened, and if two black balls appeared, the applicant would not be admitted into the fire department. In 1935, laws and regulations of the fire department stated that membership in any fire company was limited to white male citizens of the United States of at least 21 years of age. Pictured below is a fire bucket that was used in the department on the hook and ladder company. Fire buckets were used in bucket brigade fashion if the hook and ladder company arrived before the hose cart company. (Both, courtesy of the author.)

Discover Thousands of Local History Books
Featuring Millions of Vintage Images

Arcadia Publishing, the leading local history publisher in the United States, is committed to making history accessible and meaningful through publishing books that celebrate and preserve the heritage of America's people and places.

Find more books like this at
www.arcadiapublishing.com

Search for your hometown history, your old stomping grounds, and even your favorite sports team.

Consistent with our mission to preserve history on a local level, this book was printed in South Carolina on American-made paper and manufactured entirely in the United States. Products carrying the accredited Forest Stewardship Council (FSC) label are printed on 100 percent FSC-certified paper.

MADE IN THE USA